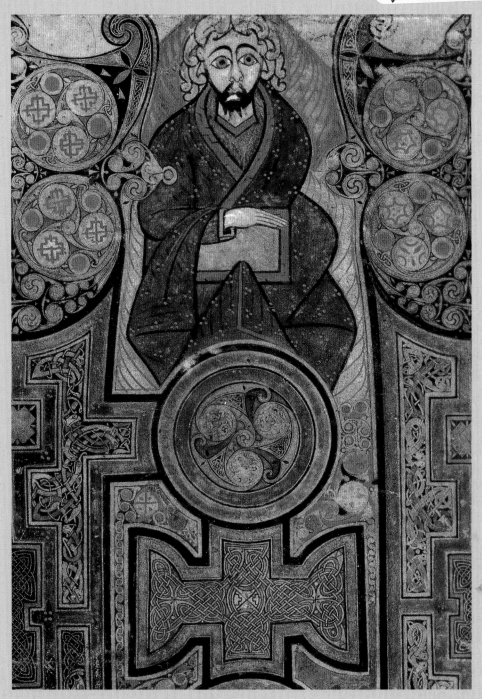

BERNARD MEEHAN

THE
BOOK OF
KELLS

AN ILLUSTRATED INTRODUCTION TO
THE MANUSCRIPT IN
TRINITY COLLEGE DUBLIN

With 117 illustrations, 110 in color

THAMES AND HUDSON

For my father and mother

Acknowledgments

Half-title:

1. *Detail of folio 292r, the beginning of John's gospel.*

Titlepage:

2. *Detail of folio 33r, eight-circle cross.*
p. 6,7:
3,4. *Folios 2r and 5r, canon tables.*

Any work on the Book of Kells is dependent on what has gone before. My own debts to published work will be clear from the notes. The following have done me the favour of reading this essay, or parts of it, in draft and offering corrections and some very helpful comments: Peter Fox, Jane Maxwell, Felicity O'Mahony (to whose powers of observation I am indebted), Stuart Ó Seanoir, William O'Sullivan, Michael Ryan and Roger Stalley. I have also benefited from the advice of John Bannerman, Mary Cahill, Aoibhean Nic Dhonnchadha, Dáibhí Ó Cróinín, Raghnaill Ó Floinn and Jennifer O'Reilly. It can safely be said that I am left with no excuses. To express this in another way, none of the above can be held liable for any faults which remain.

First published in the United States of America in 1994 by Thames and Hudson Inc.,
500 Fifth Avenue, New York, New York 10110
Reprinted 1996

Library of Congress Catalog Card Number
94-60268
ISBN 0-500-27790-7

Printed and bound in Singapore

Contents

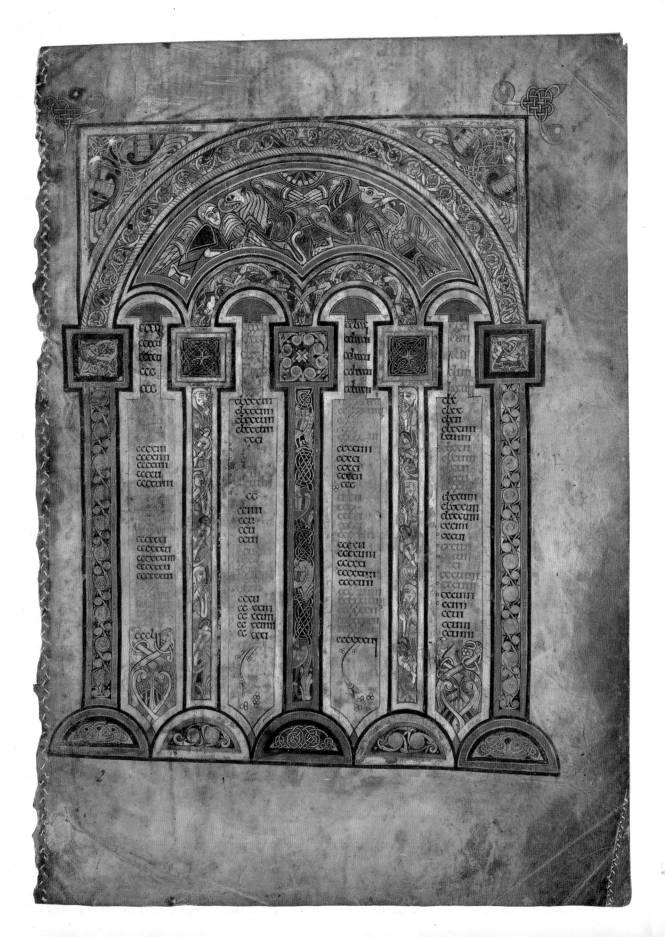

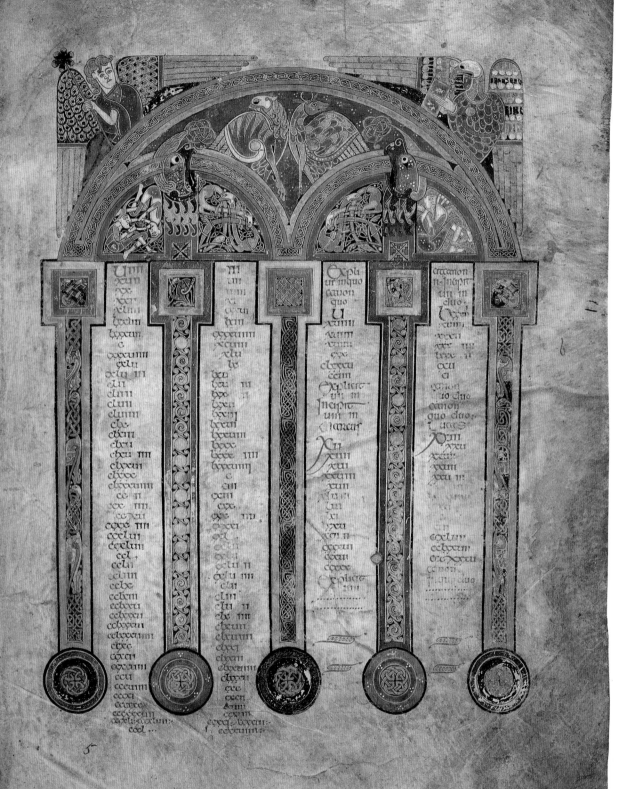

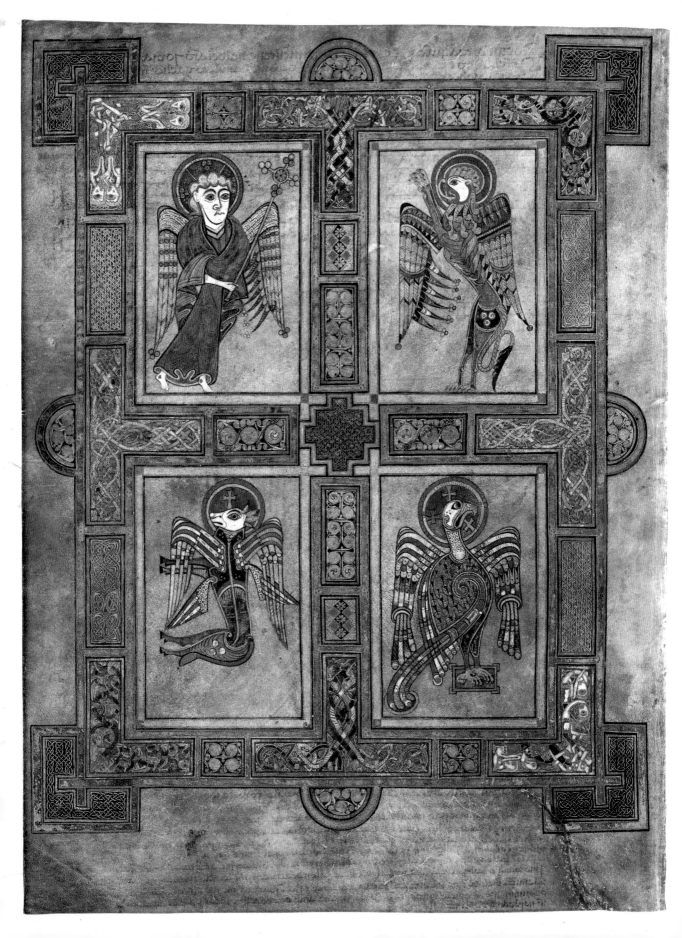

IT HAS ALWAYS been difficult to write about the Book of Kells without resorting to hyperbole. Those who have tried to describe it betray almost a sense of disbelief, as though it had emerged from another world: 'the work, not of men, but of angels', as the thirteenth-century historian Giraldus Cambrensis put it; 'the product of a cold-blooded hallucination', in the words of Umberto Eco.[1]

The Book of Kells, to express it more prosaically, is a large-format manuscript codex of the Latin text of the gospels. Preceding the gospels themselves are 'etymologies', mainly of Hebrew names (only one page survives); canon tables, or concordances of gospel passages common to two or more of the evangelists, compiled in the fourth century by Eusebius of Caeserea (so that a passage in any one gospel can, in theory, quickly be found in the others); summaries of each of the gospel narratives, known as *Breves causae*; and prefaces characterizing the evangelists called *Argumenta*. The first gospel text (Matthew) begins on folio 29r.

It is the most lavishly decorated of a series of gospel manuscripts produced between the seventh and ninth centuries, when Irish art and culture flourished at home and in centres of Irish missionary activity overseas. The artistic style of the period is commonly known as 'insular'. The Book is written in a bold and expert script of a type best described as 'insular majuscule'.[2] The text is based on the Vulgate (the version of the Bible completed by St Jerome in 384 AD) intermixed with strong elements of the version that preceded it, known as the Old Latin translation. This text is decorated and at the same time elucidated with images of great iconographic subtlety. Important words and phrases are emphasized and the text is enlivened by an endlessly inventive range of decorated initials and interlinear drawings. The great decorated pages, upon which the book's celebrity mainly rests, comprise symbols and portraits of the evangelists, introducing the gospels; portraits of Christ and of the Virgin and Child; and illustrations of the temptation and the arrest of Christ.

Where, when and why was the Book of Kells written? To answer these questions we must go back to the arrival of Christianity in Ireland probably in the fourth century, and its consolidation through the work of St Patrick and others in the fifth. The new religion was to exercise enormous patronage in

25

Opposite:
5. Folio 27v, symbols of the four evangelists.

9

the commissioning of a wide range of articles. It needed altar vessels, reliquaries, vestments, bells, staffs, flabella (liturgical fans) and above all books. 'Pocket' gospels like the Book of Dimma and Book of Mulling (Trinity College Dublin MSS 59, 60) were used for missionary work or private devotion, while larger volumes like the Lindisfarne Gospels (Cotton Nero D. IV), the Echternach Gospels (Paris, Bibliothèque Nationale lat. 9389) and the Book of Kells itself were designed for use on the altar. The Irish church developed particular characteristics, its orientation and control being primarily monastic rather than episcopal. As Roman practice changed, it came to differ from Rome in the date on which it observed Easter, and its clerical tonsure was distinctive. When the Irish entered the missionary field, problems arose from these differences. At the Synod of Whitby in 664, these were resolved, for the north of England, in favour of the Roman side. Irish missionary work in England had begun with the foundation of an abbey at Lindisfarne by St Aidan in 635.

Other Irish missionaries were prominent in continental Europe. Around 590, St Columbanus journeyed with eleven companions from Bangor, county Down, to Burgundy, founding monasteries at Fontaine, Annagray and Luxeuil before moving to Switzerland and from there to northern Italy, where he founded an influential house at Bobbio. One of his disciples, Gallus, stayed to live as a hermit in Switzerland at a place which came to be named after him. Another Irishman, St Kilian, was a missionary at Würzburg in Germany, where he was martyred in 689. The Irish missions exercised a widespread influence through their foundations, not least on calligraphy and decorative techniques. This influence can still be observed in the many insular manuscripts and artefacts which remain today in European centres.[3]

The date and place of origin of the Book of Kells have long been subjects of controversy. Investigations have ranged far and wide, but have focused particularly on two locations: Iona, an island off Mull in western Scotland; and Kells, county Meath, in Ireland. The monastery of Iona had been founded in about 561 by St Colum Cille (to whom the Book of Kells was traditionally attributed) but in 807, after a series of devastating Viking raids, it established a house of refuge at Kells and for many years the two monasteries were governed as a single community. It was close to the time of this migration that the Book of Kells must have been written. The arguments concerning the origin and date of the manuscript are set out in Appendix I.

Opposite:
6. *Folio 202v, the temptation.*

Overleaf:
7. *Folio 7v, Virgin and Child with angels.*
8. *Folio 8r, beginning of the* Breves causae *of Matthew.*

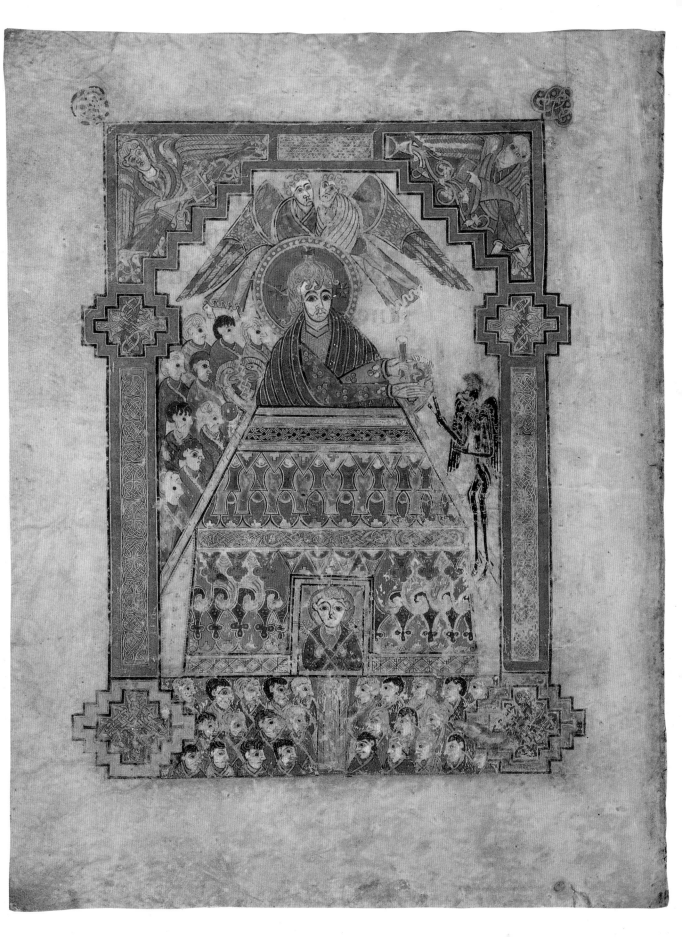

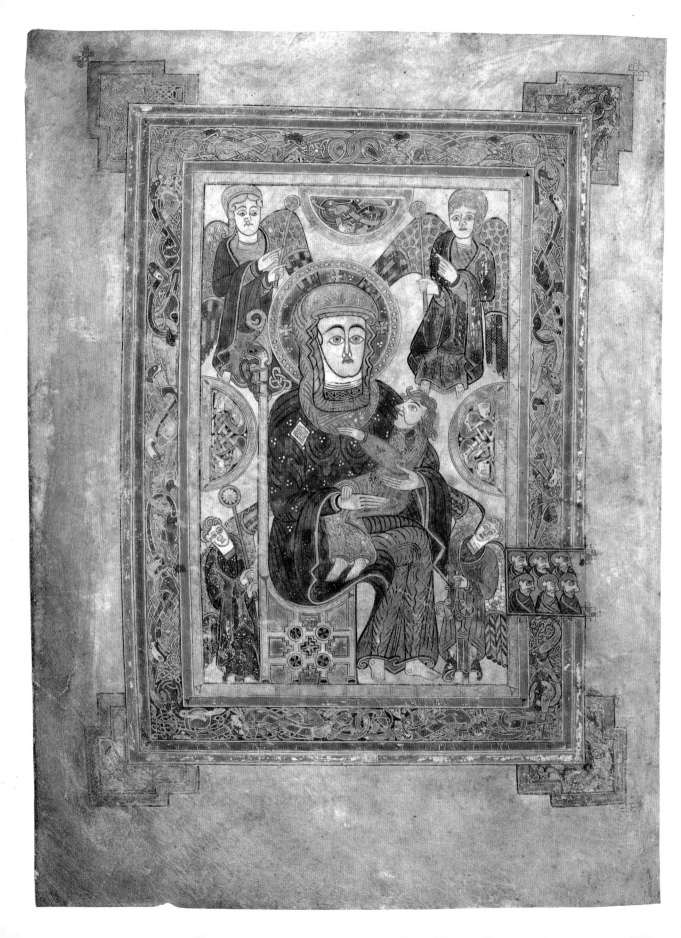

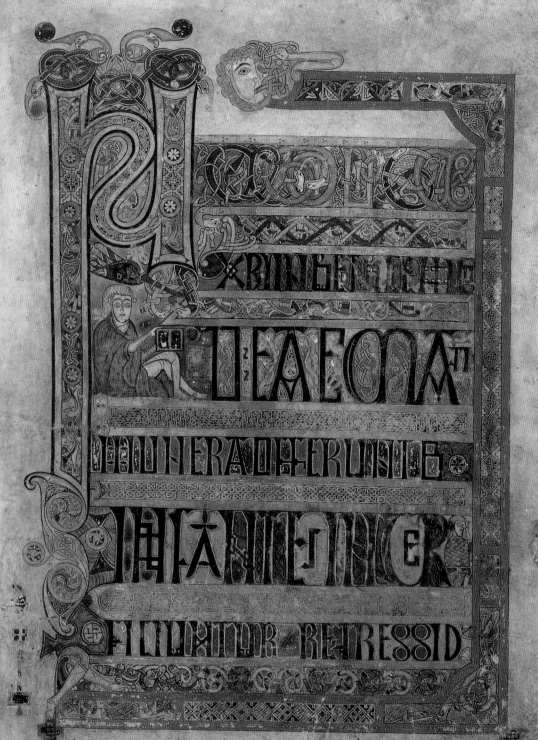

Nativitas xpi in bethlem iudae magi munera offerunt
et infantes interficiuntur.

In the middle ages the manuscript was revered at Kells as the great gospel book of Colum Cille. This was the term used when the Annals of Ulster record the theft of such a book in 1007 from the western sacristy of the great stone church of Kells and its recovery 'after two months and twenty nights' covered by a sod. It is safe to assume – though it is of course an assumption rather than a fact – that the book in question is the Book of Kells. The phrase 'the most precious object in the western world' (*primh-mind iarthair domain*) occurs in the annalistic entry, but it is not clear whether this refers to the book itself or to the ornamental shrine, stolen in the episode, which protected and enriched it. The manuscript was inarguably at Kells from late in the eleventh century, when it was used to record property transactions.[4] In 1090, it was reported by the Annals of Tigernach that relics of Colum Cille were 'brought' (by which we should probably understand 'returned') to Kells from Donegal. These relics included 'the two gospels', one of them surely the Book of Kells, the other perhaps the Book of Durrow, with which it has long been associated.[5]

In 1655, Samuel O Neale, reporting for the Down Survey, commented on the belief of the townspeople of Kells that the manuscript was 'written as they say by Columbkill's own hand, but [is] of such a character that none of this age can read it'. The book was lost to the town in the seventeenth century. The 'great stone church' of the annals had survived a transition from monastic to episcopal control in the twelfth-century reform of the Irish church, but it did not survive the disruption of the Cromwellian period, when it was in such a ruinous state that it was fit only for the stabling of horses. The governor of Kells, Charles Lambart, earl of Cavan, sent it to Dublin for reasons of safety around 1653. A few years later, it reached Trinity College, the single constituent college of the University of Dublin, through the agency of Henry Jones, a former scout-master general to Cromwell's army in Ireland and vice chancellor of the university, when he became bishop of Meath in 1661. The association with St Colum Cille persisted, at least in the popular mind, until as late as the nineteenth century, and it was as 'St Columba's book' that it was introduced to Queen Victoria in 1849. Among scholars, it was regarded in more secular terms. James Ussher, who collated its text and the text of the Book of Durrow with the Vulgate, seems to have been the first to use the term 'the book of Kelles', some time after 1621.

By the mid nineteenth century, the manuscript was on display in the Long Room of the College library, and gradually

Opposite:
9. *Folio 24r, part of the* Breves causae *of John, written by scribe B.*

Ihannif dotcimonium puũnbꝰ· electo dicitf
nonfum dignuf corrigiam calciamenti
eiuf foluere— Item iohannif dicitt
dignuf dt qui tollit peccatum mundi·

Escendit ihs discipulis suis ubi manere· &
secutasunt eum· Ubi ihs deaqua uinum fecit
inchanna galilae— Eiecit ihs extemplo om
nes uendentes & dixit domus orationif est
domuf patris mei· Quinonrhatuf fuerit denouo
exaqua & spusco nonintrabit inregnum dt—
Ubi baptizat ihs & dixit iohannis discipulis
tto nonsum xps· Ubi secessit ihs iudea &
ubiit insamariam pter bibere &c

Sedens superputeum mulierem samaritanam
et discipulis suis alii laborauerunt &uos inla
borem ipsorum introitis· Omnis propheta sine
honore ht inpatria est· suauibi filium reguli sana
uit—

assumed a new role as an art object. As such, it has attracted an enormous degree of scholarly examination.[6] Much recent research has tilled the fertile ground of biblical exegesis, concentrating on the spirituality of the book and on its relevance to liturgical practices. Attention has been drawn to the role of eucharistic ceremonies in the life of the Irish church,[7] and to the possible significance of Easter rites and festivals in the specific decoration of the Book of Kells. Increased emphasis has been placed on the importance of pericopes (short passages selected for public reading) such as Mt. 1.18, the first pericope of Christmas eve, the opening word of which is the Chi Rho monogram (Chi and Rho forming the abbreviated Greek form of the name of Christ).[8] This was elaborated to an increasing size in insular manuscripts until in Kells it took up almost the whole page.[9]

27

It is emphasised at present that certain pages and motifs are capable of carrying different layers of meaning, or at least of interpretation; that the images on the page should be read in a number of different ways simultaneously; that the complexity of the decoration mirrors the 'verbal virtuosity' of the Irish exegetes of the period, as Benedict of Aniane put it,[10] and is meditative and allusive in intent. Free association of ideas is taken to be part of the intellectual baggage of the monks. Research employing this technique, some of it carrying in itself resonances of the exegetical, has unquestionably advanced our understanding of the manuscript, though any re-creation of the spiritual world of the Columban monk must depend to a certain extent on conjecture.

Particular difficulties lie in the way of a fuller understanding of the circumstances which occasioned the production of the book, and the uses to which it was put when first it was made. Its many textual errors and the virtual illegibility of many of the major text pages and the bands of display lettering,[11] added to its sheer sumptuousness, mean that it was unlikely to have been produced for daily readings. Perhaps it was made as a piece of altar furniture intended for use only on special occasions. It may have been made for a particular event. Henry suggested that it might be possible to tie the making of the book to the bicentenary of the death of Colum Cille in 797, but this is not easily ascertained, since it is uncertain if such anniversaries were celebrated at the time. A connection has been postulated between the production of the book and the translation of St Colum Cille's relics to a new shrine in the middle of the eighth century,[12] but this date seems around a generation too early for

the Book of Kells. If we are able to accept that manuscripts were produced for events such as this, it might be supposed that a different gospel book, though one now lost, was produced for the occasion. Perhaps we can reach no closer than to conclude that the book came about through the happy conjunction of a perceived need and the opportunity afforded by the presence of several artists of conspicuous talent.

During the last century, the Book of Kells, both in Ireland and abroad, has become an inspiring symbol of Irish nationality and creativity. Remote as the modern mind is from its arcane imagery, there is a lasting recognition of the artists' skills and devotion and an enduring fascination with the enigma surrounding its production.

The repertoire of ornament employed in the Book of Kells had long been in development in manuscript art and applied crafts. Red dots used around the shape of a letter for the purposes of highlighting it appear first in the earliest surviving Irish book, the gospel manuscript known as 'Usserianus primus' (Trinity College Dublin MS 55), which dates from the late sixth or early seventh century. In the device known as 'diminuendo', the letters of words introducing a new section are formed in decreasing sizes. The earliest appearance of this technique in an Irish context is in the Cathach (Dublin, Royal Irish Academy, 12. R. 33), a psalter traditionally, and perhaps correctly, attributed to the pen of St Colum Cille. The two devices are commonly used in tandem in the Book of Kells to pick out the opening letters of verses. Interlace, which in the Book of Kells reached a high order of ingenuity, developed from the art of antiquity. The first surviving insular manuscript to use interlace – in a static, ribbon pattern – was a fragmentary late seventh-century gospel book now at Durham (Dean and Chapter Library, MS A.II.10). In the later seventh-century Book of Durrow (Trinity College Dublin MS 57) interlace took on zoomorphic as well as abstract elements in designs which, combined with the complexity of Celtic spiral and trumpet devices, point the way towards the sophistication of Kells. In Durrow, parallels with the motifs of jewellery and metalwork are particularly striking.

It is not possible within the scope of this study to provide more than a sketch of the varied artistic models and predecessors of the Book of Kells. The extent to which the manuscript was paralleled by the art of the Mediterranean countries, and by Byzantine, Coptic, Assyrian, Armenian and other sources is a matter of debate. Devices like the snake ornament of folio 33r or

Decorative influences and parallels

26

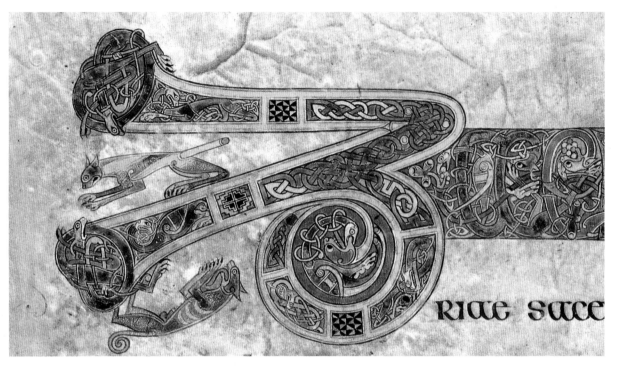

10. *Detail of folio 19v, part of the* Breves causae *of Luke.*

the joint articulation of animals, seen, for example, in folios 19v, 76v or 302r, are found in the Pictish stone carvings of Scotland. There is no agreement on the direction in which this influence was running; on whether, in other words, the manuscript artists were influenced by sight of the carved stones, or, as is likely, the stone carvings were copied from the more portable medium of books. The style probably originated from the common source of metalwork, perhaps from the technique of cloisonné enamel.[13] What seems indisputable is that once a motif, whether figurative or symbolic or purely ornamental, is employed in any medium, it enters a common currency of decoration, and can be borrowed, re-used and adapted.

Parallels with metalwork as well as stonework are frequently to be observed. On pages like 34r and 124r, the use of tight red dotting on a blank ground is reminiscent of stippling on metalwork, such as on the bowl of the Ardagh Chalice. Many parallels can be observed in subject matter. One example is a small circular mount found at Togherstown, County Westmeath (National Museum of Ireland 1929: 1400) which contains three figures grasping each other's legs. This is similar to three roundels at the top of folio 130r, with the difference that in the manuscript the figures grasp each other's arms. Several parallels together are found in two dismembered finials from

10
11,105

27, 62

13

12

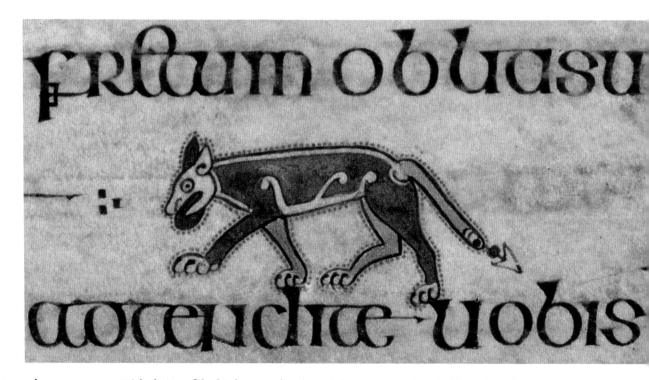

what was once an Irish shrine of the highest quality (now Musée des Antiquités Nationales, St Germain-en-Laye, France: 52 748 [a, b]). Its bosses are similar to those on 33r; its snake ornament is of a type used extensively in Kells; and the human head, here within a snake's jaws, and long curved neck resemble the initial on folio 58v. Other heads in the Book of Kells, such as the portrait of Christ at his arrest in folio 114r, with its prominent, bulging eyes and precisely formed beard, resemble a small eighth-century Irish head once part of another metalwork shrine.[14] A remarkable late seventh- or early eighth-century hoard discovered in 1985 at Donore, only a few miles from Kells, displays several, unsurprising parallels with the art of the manuscript, not least in the similarity between the profile lion of the cast-bronze door handle and the biting lion of folio 124r. The trumpet and spiral motifs of one of the discs from the hoard is close in style to those of folios 33r and 34r, the designs in both media constructed through the use of compasses. In a different medium again, a small bone pin of a man squatting, his arms wrapped around his knees in a naturalistic pose, was found last century at Newbridge, County Kildare (NMI W 13). This resembles a figure in folio 86r line 2, forming the *T* of *Tunc*, and the tiny detail of a man, upside down, clasping his knees at the top of the shaft of the first *I* of the *Initium* page (folio 130r).

11. *Detail of folio 76v, with a wolf embellished by Gerald Plunket in the sixteenth century.*

12, 13. *Detail of folio 130r, with figures in roundels grasping each other's arms; and Togherstown mount, where they grasp each other's legs.*

14, 15. *Detail of folio 86r showing a squatting man, and similar figure on a small bone pin from Newbridge, Co. Kildare.*

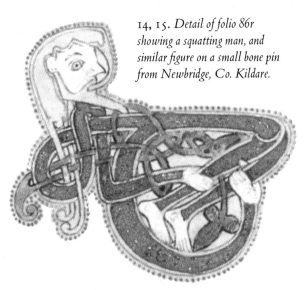

16, 17. *Detail of spirals in the eight-circle cross (folio 33r), and an engraved disc from Donore, Co. Meath.*

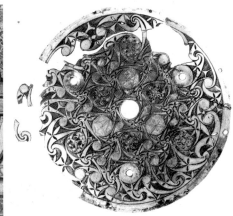

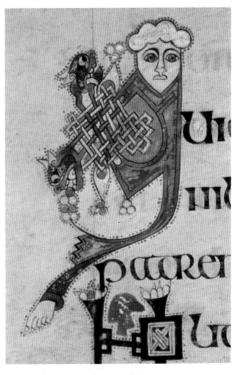

18, 19. *Initial from folio 58v and (left) similar head on early ninth-century finial at St-Germain-en-Laye.*

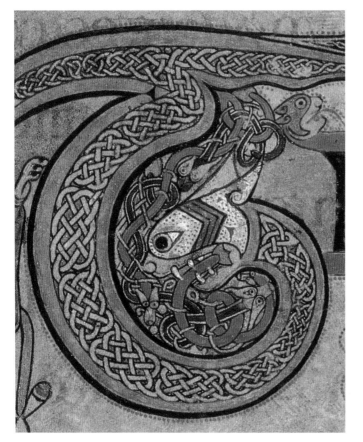

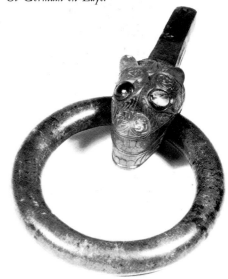

20, 21. *Detail of lion head on folio 124r and similar handle from Donore, Co. Meath.*

The scheme of decoration

The Book of Kells integrates and develops its decorative inheritance with breathtaking assurance, embellishing the text on every page. Two pages (folios 29v and 301v) lack colour, but it was not planned that this should be so. The text on folio 29v is framed with an elaborate, unfinished design in ink. In the case of folio 301v, the bowl of the letter *a* on line 11 was lightly decorated by the scribe, but no pigment was added.

The major decorated pages are complex in composition and iconography. They comprise canon tables (folios 1v–6r); pages grouping symbols of the evangelists (folios 1r, 27v, 129v, 187v and 290v); a depiction of the Virgin and Child surrounded by angels (folio 7v); portraits of St Matthew (folio 28v), Christ (folio 32v) and St John (folio 291v); narrative scenes, the earliest to survive in gospel manuscripts, representing the arrest and the temptation of Christ (folios 114r, 202v); a page wholly of decoration depicting a double-armed cross with eight roundels embedded in a frame (folio 33r). The famous Chi Rho page (folio 34r) introduces St Matthew's account of the nativity. The opening words of each of the gospels are elaborated extensively: *Liber generationis* (Mt. 1.1) on folio 29r; *Initium euangelii iesu christi* (Mk. 1.1) on 130r; *Quoniam* (Lk. 1.1) on 188r; and *In principio erat uerbum {et} uerbum* (Jn. 1.1) on 292r. Other passages given additional decorative emphasis are on folios 8r (the opening of the *Breves causae* of Matthew); 13r (the beginning of the *Breves causae* of Mark); 12r, 15v, 16v, and 18r (the opening words of the *Argumenta* of the four gospels); 19v (the words ZACHA[*riae*] at the opening of the *Breves causae* of Luke; 114v (the opening of Mt. 26.31, *Tunc dicit illis ihs omnes uos scan*[*dalum*]; 124r (Mt. 27.38, *Tunc crucifixerant xpi cum eo duos latrones*); 183r (Mk. 15.25, *Erat autem hora tercia*); 200r–202r (Lk 3.22–38); 203r (Lk. 4.1, *Ihs autem plenus spiritus sancto*); 285r (Lk. 23.56–24.1, . . . *Una autem sabbati* . . .).

The decorative plan appears to have been that each of the gospels should be introduced by a page of evangelist symbols, a portrait page and an elaboration of the opening words or letters. It was common for pages of major decoration to be painted on single leaves, so that the transcription of the rest of the text might continue without interruption on conjoint leaves while the more time-consuming task of decoration was in progress. Single leaves were liable to become detached and lost or misplaced in subsequent bindings. This may explain why no portrait now accompanies St Mark's or St Luke's gospel. Some uncertainty attaches to folio 187v, at the end of St Mark's gospel, which may

6,7
5,38
31,36
7,35
63,37

54,6

26

27

25
56,94
30
8

57

62,113

22

28,33

Opposite:
22. *Folio 200r, beginning of the genealogy of Christ (Lk 3. 22–26).*

factus est uox filius meus dilectus in te·

bene complacuit mihi·

Et ipse ihs erat incipiens quasi an

norum triginta ut putabatur filius

ioseph

QUI fuit heli

QUI fuit matha

QUI fuit leui

QUI fuit melchi

QUI fuit iannae

QUI fuit ioseph

QUI fuit mathat hie

QUI fuit amos

QUI fuit nauum

QUI fuit esli

QUI fuit nagge

QUI fuit enath

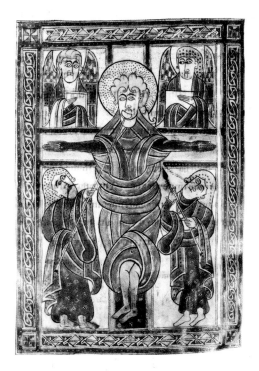

23. *Crucifixion from an Irish manuscript at St Gallen.*

24. *Detail of folio 188r, showing cloak to which it was intended that a man's head should be added.*

Opposite:
25. Folio 29r, Mt 1.1, Liber generationis.

Overleaf:
26. Folio 33r, eight-circle cross, inverted from its present position, but probably conforming to the original scheme of the manuscript: see p. 94, n. 15.
27. Folio 34r, Chi-Rho page (Christi autem generatio).

have served, though incomplete, as a symbols page for the following gospel, that of St Luke. The present placement of several pages is doubtful. It seems likely that the cross-carpet page at folio 33r originally faced folio 34r.[15] 26,27

It is evident that the Book of Kells was not completed. A crucifixion scene was probably intended for the blank page 123v, where it would have been observed by onlookers gathered in groups on folio 124r. It was normal practice in the manuscript 62 for the reverse of pages bearing elaborate decoration to be pricked and ruled for text with more than normal care. This was the case for folio 123r, though its verso remained blank. The intended image may have been similar to that in the Durham Gospels (Durham, Dean and Chapter Library, A.II.17 folio 38³v). It is also possible, as Françoise Henry suggested, that an image of the Last Judgment was planned for folio 289v. Such an image – or it may be an ascension – occurs in the eighth-century 23 Irish manuscript St Gall 51 p. 267, a manuscript which also has an image of the crucifixion on p. 266. The plan of folio 29r was 25 changed in several places. Compass circles are left unused, and the original scheme for the roundel in which the *ER* of *LIBER* was placed underwent a simplification, intricate snake decoration being left less than half completed, and the roundel being filled with a single wash of yellow. The face of the angel at the top left of 29r was given no features. On 95r, the head emerging from a decorated *Et* was provided with eyes but neither nose nor mouth. The decoration of folios 30r–31v was begun, but came 117 to a halt at an early stage. On other text pages, like 301v–302r, the colouring process was not concluded. On 188r, it was surely 24 intended that a head should be added to the cloak at the top of the page, and placed, like its companions, in the mouth of a lion. On 288r, a lion was left unfinished at the right of the page. There is something strange and uncharacteristic about the decoration of folio 203r in the context of the other decorated pages which 28 may be explained if it is work done later or not completely finished.

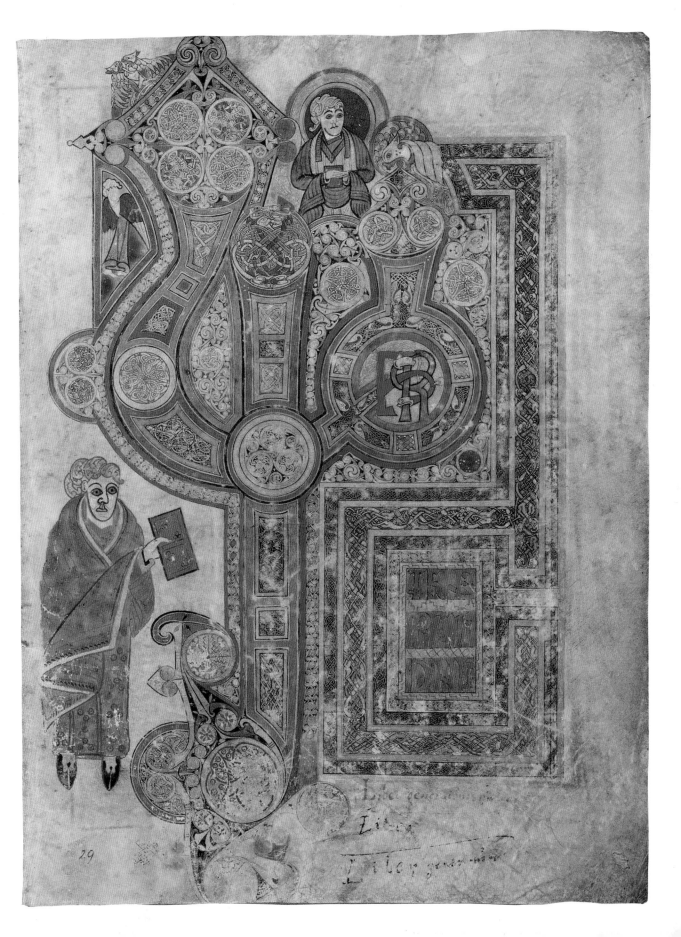

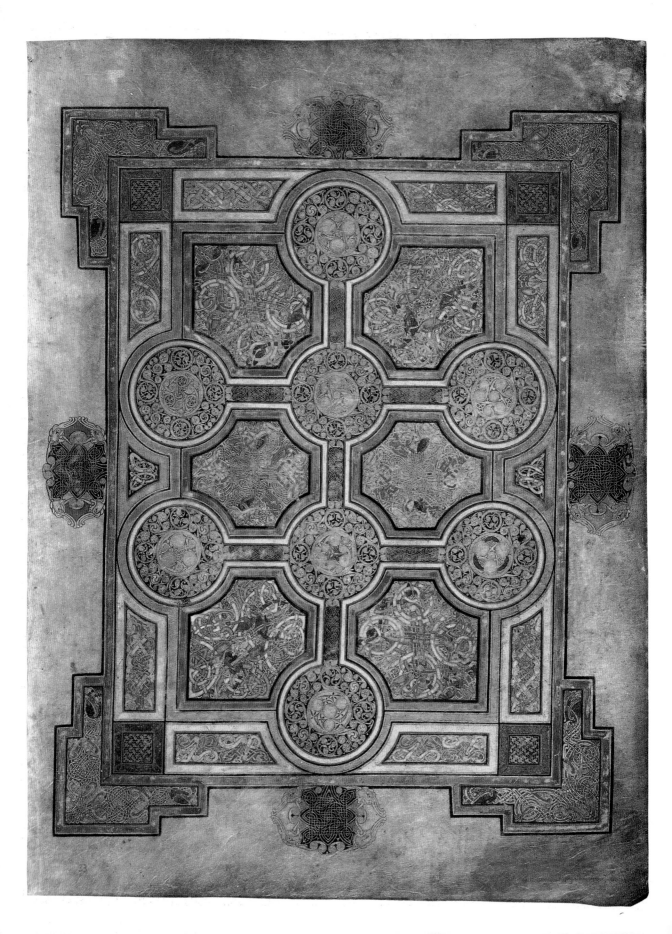

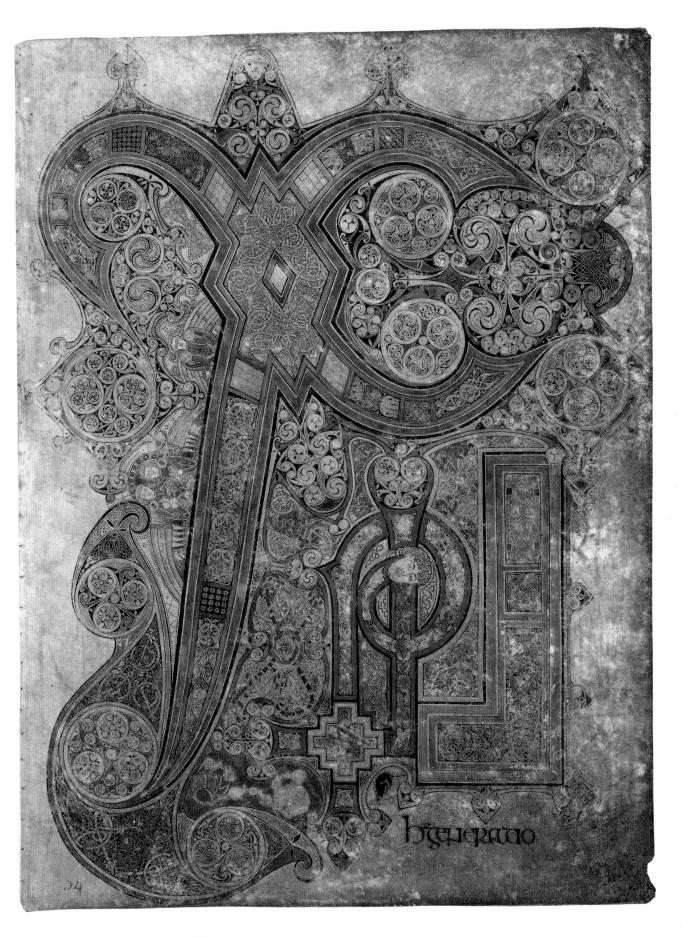

ḃ generatio

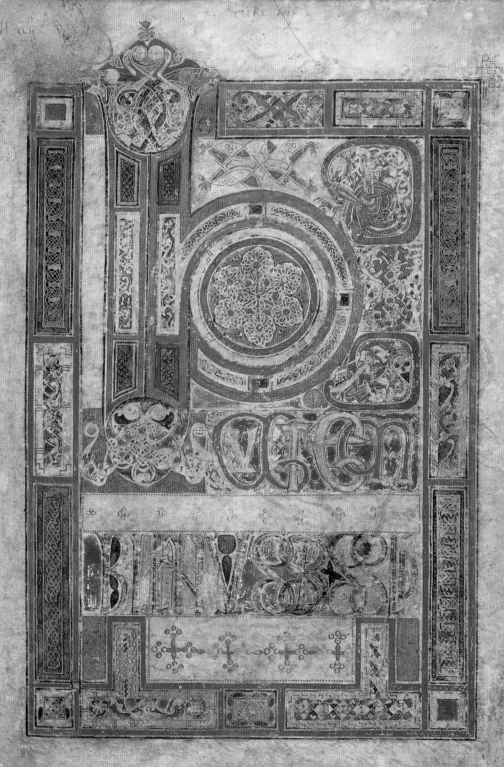

Jesus andein plomus S. S.

The decoration of the text pages was mostly of the initial letters of verses, forming part of the text itself rather than serving as an adjunct to it. Hence, decoration punctuated the text and aided legibility, at the same time repeating the thematic preoccupations of the fully decorated pages. These functioned in a number of different ways. They continued the text. They illustrated it. They had a liturgical use. They also had an evangelical purpose. The importance of the visual in instructing the uninitiated was recognised from the outset by missionaries. Pope Gregory the Great explained that images provided 'a living reading of the Lord's story for those who cannot read'. This was why images were used in a missionary context. Bede explains in the *Historia Ecclesiastica* that when St Augustine came to England to preach the gospel in 597, he came bearing 'a silver cross and an image of our Lord and Saviour painted on a panel',[16] which he raised high for king Ethelberht to see. It was important that the icons of Christianity should impress by their splendour. In 735 St Boniface, the English missionary to the Germans, commissioned from the abbess Eadburga a copy of the epistles of St Peter written in gold, so that, as he said, he might impress honour and reverence for holy scripture before the eyes of the carnal in his preaching.[17] In larger manuscripts, the overall sweep of designs was constructed in such a way as to make them visible at a distance to a congregation sitting in the body of the church. The Echternach gospels contains such an image in which St Matthew displays his gospel in an open position (Paris, Bibliothèque Nationale MS lat. 9389 folio 18v). The opening words can be seen (*Liber generatione ihū xpi*), but no decoration is visible. A manuscript could be observed in this way on the altar, and recent research has made it clear that gospel books were displayed to the faithful in processions.[18] Intricate and detailed decoration, like the roundels of folio 33r, was for contemplation only by those who had access to the manuscript. Not all of the elaborated pages of key phrases are immediately legible, nor, it might be argued, were they necessarily intended to be. They functioned as an aide memoire for those already familiar with the text, and familiar with patristic writings and exegetical texts which alluded to the themes it is possible to discern in the Book of Kells. The artists did not necessarily comprehend the full significance of all that they were copying. Some details may have been half remembered, imperfectly understood, or inaccurately copied.

The purpose of the decoration

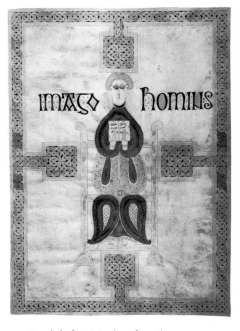

29. *Symbol of St Matthew from the Echternach gospels.*

Opposite:
28. *Folio 203r, Lk 4.1* (Iesus autem plenus spiritus sancto).

The sacred text itself was copied in the Book of Kells with a remarkable degree of inaccuracy. For today's observer many of the images in the book can be understood only imperfectly. The current idea that the images could carry composite or 'multivalent' meanings even for their artists is an extraordinarily useful but potentially misleading device. If we bring to texts so rich in interpretive possibilities an original readership which knew scripture well, and artists as skilful and apparently as allusive as those of the Book of Kells, the possibility does occur of several equally plausible interpretations of particular pages or motifs. Since however there is so little chance that the artists' intentions can be proved, we are also in danger of coming eventually to the position that the pages mean whatever we want them to mean. Yet around the time of the writing of the Book of Kells, it was widely acknowledged that scripture presented difficulties of interpretation and needed careful exegesis. Adomnán exemplifies this idea in his account of visions experienced by St Colum Cille, particularly in his comment that 'everything that in the sacred scriptures is dark and most difficult became more plain' as a result of an ecstatic vision.[19] Adomnán reinforces too the individual nature of Colum Cille's enlightenment. His visions are of an intensity which would blind those less worthy. The interpretation of spiritual matters was only for the elite. As Colum Cille announced to his disciple Lugbe, 'There are some, although few indeed, on whom divine favour has bestowed the gift of contemplating, clearly and very distinctly, with scope of mind miraculously enlarged, in one and the same moment, as though under one ray of the sun, even the whole circle of the whole earth, with the ocean and sky about it'.[20]

Decorative themes: the book and the cross

Giraldus Cambrensis maintained that close study would reveal 'ever fresh wonders' in a manuscript like the Book of Kells. This cannot be disputed, but the wonders of the manuscript are those of technique and variety rather than theme, which in essence is singular. The decoration of the entire manuscript glorifies aspects of Christ's life and message and reflects the principal moments of that life. There are recurring images of Christ's birth, his sacrifice, commemorated in the institution of the eucharist, and his resurrection. His name and face, his properties, attributes and symbols are constantly before the reader, in a form of counterpoint with the text of his life.

The book was the medium which conveyed the fundamental message of Christianity. The opening words of the

Opposite:

30. *Folio 292r, the beginning of St John's gospel (*In principio erat verbum *– 'In the beginning was the Word').*

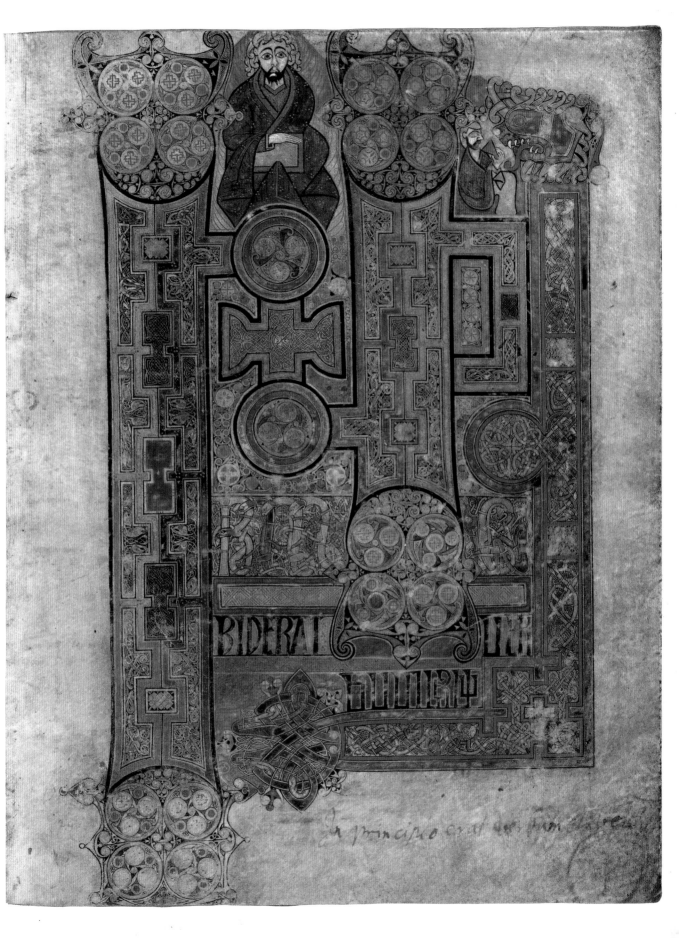

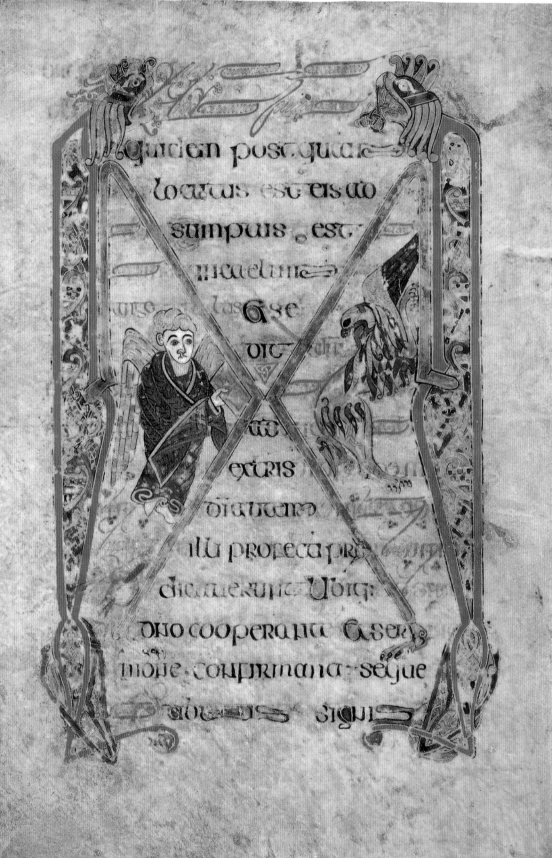

gospel of St John stressed this by opening with the statement, 'In the beginning was the word'. The book itself is a constant motif in Kells, depicted over thirty times. It is in the hands of Christ on folio 32v, of the evangelists Matthew and John (28v, 291v) and the evangelist symbols (1r/v, 2v, 3r/v, 4r, 5r, 27v, 290v and 292r). It is brandished by angels on 3r, 34r, 183r, 202v and 285r. Books are also seen in the hands of more enigmatic figures on 1v, 4r, 8r, 29r and 187v. Dr Farr has suggested that the figure on the left of 29r, as well as other figures in the manuscript, is the deacon. The deacon was sixth of the seven clerical orders, just below the priest himself. Appropriately, he was responsible for the altar and its furnishings and read the gospel at mass.[21] Books were regarded as having talismanic properties, and are known to have played a central role in life on Iona. In Adomnán's time, for example, the monks there placed books of St Colum Cille on the altar along with his garments in an attempt to gain favourable winds for the passage by sea of timbers to be used in construction work.

The cross was an explicit reminder of Christ's passion and death. A full page was devoted to the cross in the Book of Durrow, and a similar image is on folio 33r of the Book of Kells. The cross occurred as a prominent feature of manuscripts at least as early as the Coptic Glazier codex (Pierpont Morgan Library, New York, Glazier 67) written close to the year 500, and in Usserianus primus (Trinity College Dublin MS 55) folio 149v around a century later. In this position and in its use on book covers, there is a sense in which the cross served an apotropaic or protective function. For early Christian writers, the cross also had a cosmological value, in signifying the celestial axes from east to west and from north to south.[22] Countless crosses, taking every imaginable form, occur throughout the Book of Kells. Display script forms a cross on 124r. On 114r, Christ's limbs are arranged in a cross shape. A saltire cross is on 187v and 290v. Further crosses are inside the Virgin's halo on 7v. On the same folio, the upper left corner extension has ribbon interlace worked in such a way that a cross is formed. Elaborate crosses surround St John in his portrait on 291v, with crosses worked into the interlace designs at the top and foot of the figure. Crosses occur inside the bodies of individual letters, and as interlinear devices, in every form which the ingenuity of the artist could muster. Striking examples are on folio 174r (between lines 15 and 16) and on 314r (last line). In the Passion sequence in St Luke's gospel, most notably on 283r, cross forms dominate the page.

Opposite:
31. *Folio 187v, the concluding words of St Mark's gospel.*

Angels

Taking their name from the Greek word for 'messenger', angels were an unseen but constant spiritual presence, intermediaries between God and man. They had sight of God in heaven and it was known that they would be with him at the Last Judgment. Christ was surrounded by angels at the most important moments of his life on earth. They were present at his birth (Lk. 2.9–15), and on 7v, where he is on the knee of his virgin mother. This page faces the reference to his birth in the *Breves causae* of Matthew on 8r. Three angels appear on the Chi Rho page (folio 34r) at the moment of the nativity (Mt. 1.20, 24). Angels were with Christ in the desert (Mt. 4.11) and in his agony (Lk. 22.43). They were prepared to defend him when he was arrested (Mt. 26. 53) though no angels appear on folio 114r, where the arrest is shown pictorially, or on folio 116v–117r, where it is described in the text. Angels also witness Christ's resurrection (Mt. 28.2–7 and Jn. 20.12), and appear on folio 285r, at the resurrection narrative in Luke. On this page, on 7v, 32v and 202v, angels appear in groups of four. These are probably to be identified as the principal archangels, Michael, Gabriel, Raphael, and Uriel,[23] bearing flabella, flowering boughs or books, where the image becomes a precise one of the messenger bearing the message.

7

8

32

54

33

63,6

Above:
32. Detail from the Chi Rho page, folio 34r, turned at right angles, showing three angels.

Opposite:
33. Folio 285r, the beginning of Lk 24, with four angels.

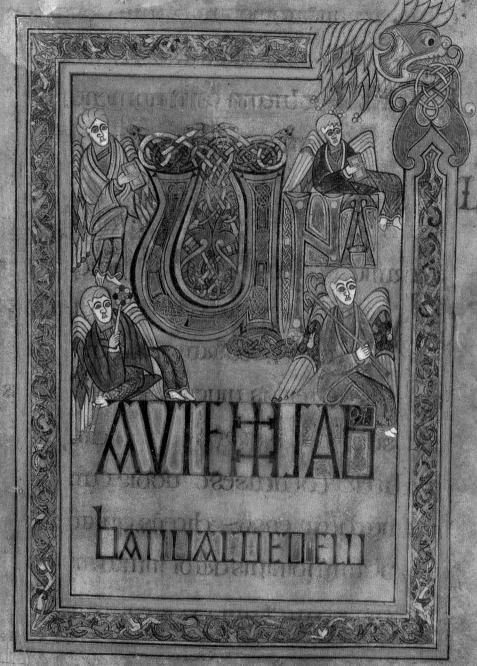

LVK XX

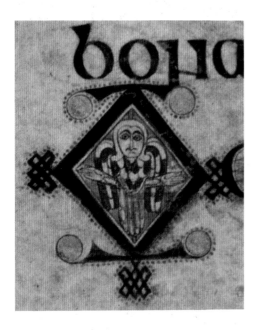

34. *Detail of folio 48r, angel in an* orans *pose.*

The evangelists and their symbols

Opposite:
35. *Folio 28v, portrait of St Matthew.*

Overleaf:
36. *Folio 290v, symbols of the four evangelists.*

37. *Folio 291v, portrait of St John, with the tools of a scribe.*

The sight of angels was afforded only to the worthy. St Colum Cille was 'held worthy to receive in shining light the sweet and most pleasant visitations of holy angels'.[24] The frequent references to angels in Adomnán's life, occupying the whole of the third book, are paralleled in the decoration of the Book of Kells. Angels, like the sacred book, helped to make clear the unseen mysteries of faith, but only for those who were prepared or were in a position to see. Several of the angels in Kells are obscurely placed, especially so on the last line of folio 48r, where a winged angel in an '*orans*' pose, with hands outstretched in prayer, is placed within the initial O of *Omnia*. The drawing of this angel is similar to those in an eighth-century manuscript probably copied in Würzburg from an Irish model (now Würzburg, University Library M.p.th.f.69 folio 7v).[25] Angels assisted Colum Cille, as the gospel book did, in the work of evangelism, by striking the pagan magician Broichan[26] and by engaging in fearsome battles with demons. In one case the demon carries a rod, as the Devil does in folio 202v. Colum Cille was often observed by his contemporaries in the company of angels, taking on, for hagiographical purposes, the attributes of Christ himself. One angel whom he met in a vision carried a 'glass book' (*vitreum . . . librum*). Colum Cille was accustomed, Adomnán tells us, to see 'the souls of just men borne by angels to the height of heaven'.[27] In his turn, the saint's own soul was accompanied to heaven by great hosts of angels, the island lit bright by their presence.

6

Two of the evangelists are portrayed on 28v and 291v, fixing the viewer with a direct stare. St Matthew holds his gospel in his left hand. Although his pose is upright, he is placed against a chair or throne, which features the symbols of his fellow evangelists, and is set in a frame composed of snake ornament. St John, extravagantly haloed and seated on a throne, his scribal accoutrements to hand, is one of the most powerful images in the entire book. The feet, hands and haloed head of another figure are at the centre of the outer edges of the frame. The figure was partially dismembered by a binder's knife in the nineteenth century, and the short, bifurcated flowering rod held in his right hand has been badly damaged by abrasion. Since part of the left hand and half of the head are now missing, identification is problematic. Against suggestions that it represents God embracing the cosmos, Dr Werner favours an indirect representation of Christ crucified.[28]

35, 37

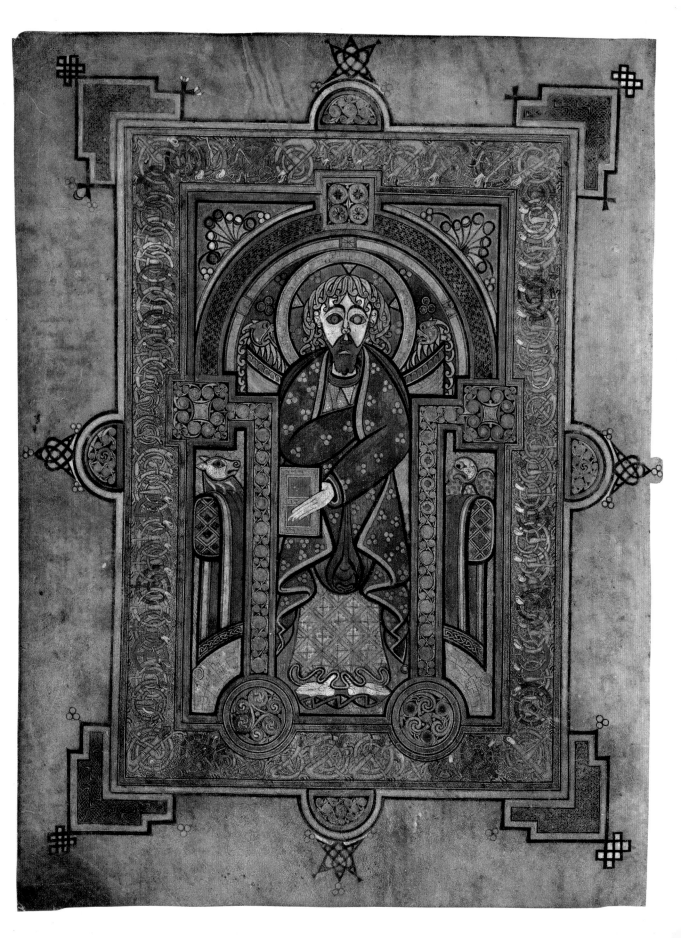

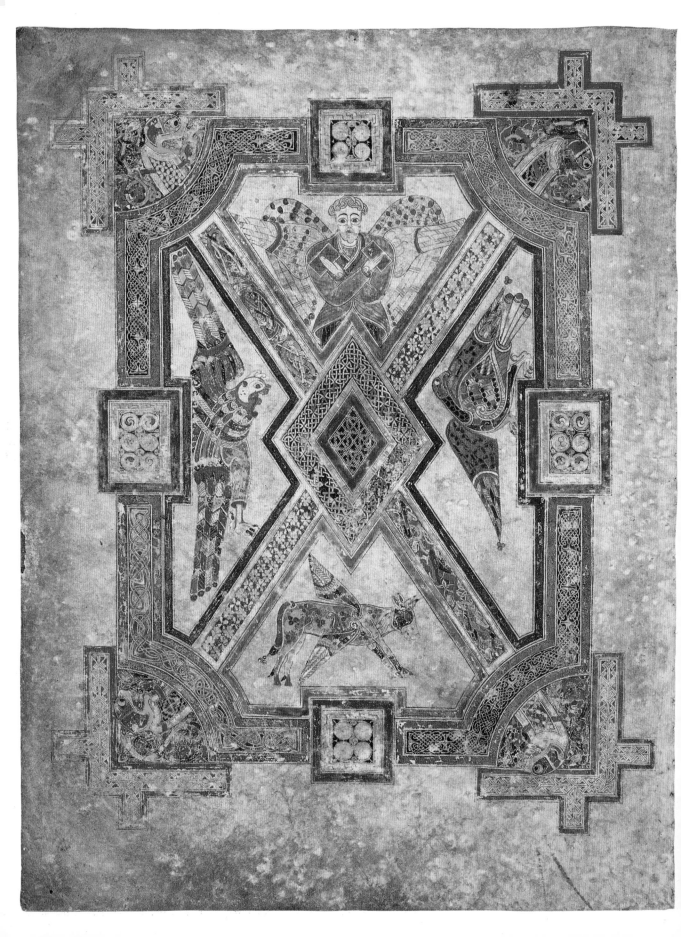

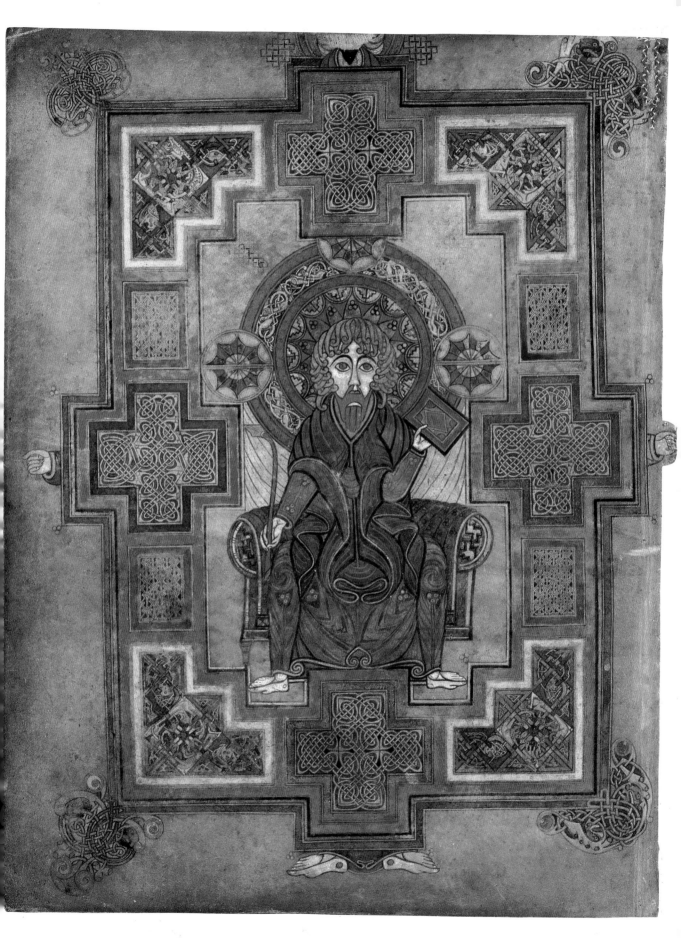

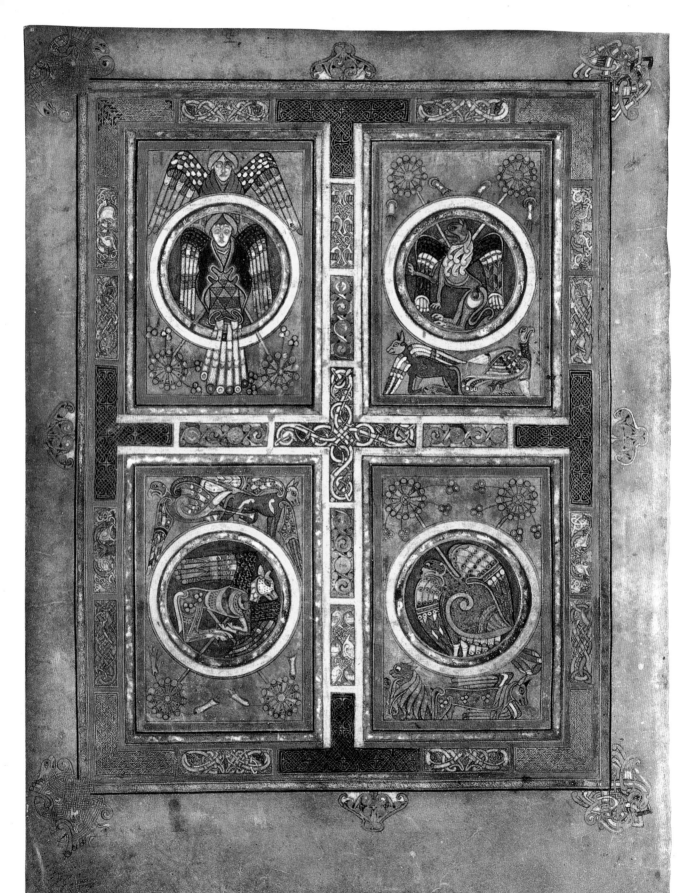

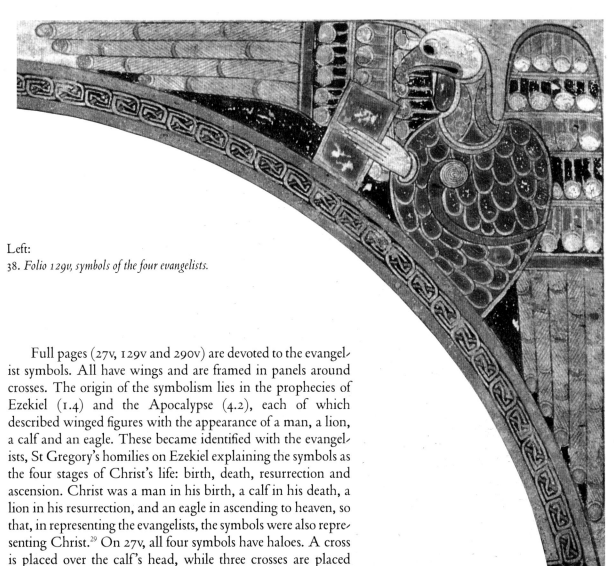

Left:
38. *Folio 129v, symbols of the four evangelists.*

5,38,36 Full pages (27v, 129v and 290v) are devoted to the evangel⸍
ist symbols. All have wings and are framed in panels around
crosses. The origin of the symbolism lies in the prophecies of
Ezekiel (1.4) and the Apocalypse (4.2), each of which
described winged figures with the appearance of a man, a lion,
a calf and an eagle. These became identified with the evangel⸍
ists, St Gregory's homilies on Ezekiel explaining the symbols as
the four stages of Christ's life: birth, death, resurrection and
ascension. Christ was a man in his birth, a calf in his death, a
lion in his resurrection, and an eagle in ascending to heaven, so
that, in representing the evangelists, the symbols were also repre⸍
5 senting Christ.[29] On 27v, all four symbols have haloes. A cross
is placed over the calf's head, while three crosses are placed
around the head of the eagle. The man for Matthew carries a rod
topped with a flowering cross, while the eagle clutches his
38 gospel. The symbols on 129v lack the explicit addition of
haloes, but are enclosed within prominent yellow circles which
may perform the same function. The man shares his frame with
another like image, or perhaps the representation is that of an
angel; the lion is accompanied by the calf and the eagle; the calf
is with the eagle and, perhaps through error, another calf, where
a lion might have been expected; and the eagle is with the calf
and the lion. The intention is to stress the unity of the gospels
despite their diversity of authorship and approach. Flabella are
prominent inside each of the panels.

Above:
39. *Detail of folio 5r, a canon table, showing
the eagle of St John.*

Left:
40. Detail of folio 4r, a canon table, showing the lion of St Mark.

Opposite above right:
43. Details of figures in the columns of canon table, folio 2r.

Opposite below:
44, 45. Two small human figures from folios 329v and 8r.

41, 42. Eagle of St John from the Book of Armagh, with (right) a similar eagle on folio 212v.

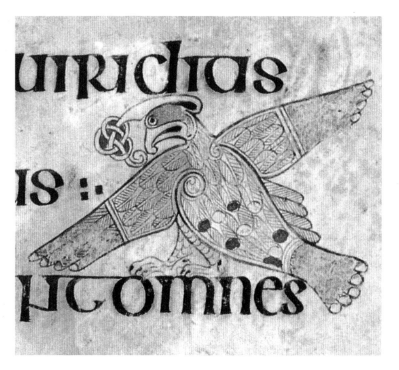

In the preliminary texts the symbols take diverse forms. On 1r they occupy the second column. Facing left to right, they are placed in the following order: man, lion, eagle, calf. The conventional forms appear in the canons from 1v–3r, but on 3v, the lion has the hooves of a calf, and the calf is given the mane and paws of a lion. The man is in an unusual squatting position, accommodating to the shape of the arch. On 4r, the calf, in an odd, spreadeagled representation, has the tapering torso, ears and paws of a lion, and three spikes suggestive of a mane. The eagle on folio 5r holds his gospel with a human hand.

Stray allusions to the evangelist symbols may occur elsewhere, such as the calf of Luke on 201v. The eagle, or at least a generalised raptor, more common then than now, is recognisable in several places, such as 174v, or 273v, where it is in flight. The eagle on 212v resembles strongly the symbol of St John in the Book of Armagh folio 90r. It may be possible to explain as symbols of St Matthew some of the small human figures which occur throughout the book, such as the man in the first column of numbers on 1v, or the figures on 8r, one of whom holds an open book or wax writing tablets, or those who occupy the supporting columns of 1v, 2r and 3v. Why they pull their own and others' beards is not clear here, or on 329v. The ubiquity of the lion is discussed below.

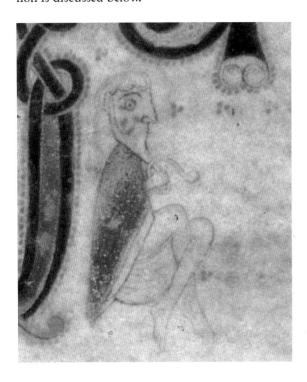

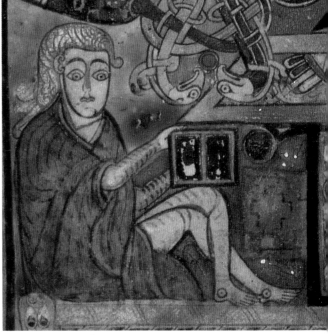

Eucharistic symbolism

Suzanne Lewis in 1980 emphasised the eucharistic nature of the imagery of the Book of Kells.[30] While points of disagreement have arisen concerning details of her work, there has been general acceptance of the thrust of her argument. To present her analysis of folio 34r in simple terms, she suggested that the disc in the mouths of mice is eucharistic bread in the form of a host (it does not seem possible to dispute this, given that the disc is marked with a cross), that the fish in the mouth of an otter represents Christ, and that the object between the moths at the top left of the page is a chrysalis, a natural symbol of rebirth and renewal. Together, these images represent a cosmological entirety of christological and eucharistic symbolism.

Symbolism of this nature is pervasive, and is denoted directly by eucharistic hosts. On folio 48r, a cat catches a mouse with a host. Suzanne Lewis felt that this alluded to the verse below it: 'what man is there among you, of whom if his son shall ask bread, will he reach him a stone?' (Mt. 7.9). The drawing may also reflect the phrase above it on the page, 'Ask, and it [?the eucharist] shall be given you' (*Petite et dabitur uobis*. Mt. 7.7). There may also be traces here, and in the similar detail on 34r, of the medieval dilemma over the implications of allowing a mouse to seize and eat a consecrated host and thus, arguably, to consume Christ. Given the undoubted prevalence of rodents, care of the communion bread must have been a perpetual concern.[31] On 29r a crossed host device in red is in the mouth of a lion at the top of the page. Hosts appear on many pages, including 260v, 266v, perhaps on 271r, on the symbol of the calf on 27v, at the foot of 292r, on 32v, and on 200v, appended to the Q of the fourth line. Several pages – 19v and 188r, for example

48

49

46

47

95

46, 47. *Eucharistic symbols in the mouth of a lion (folio 29r) and on the leg of the calf, symbol of St Luke (folio 27v).*

48, 49. *Two details of mice or rats holding the host, on folios 48r (top) and 34r (bottom).*

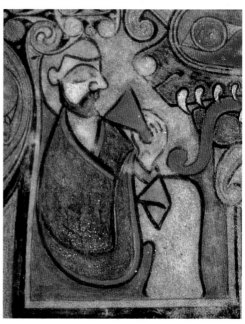

50, 51. *Details from folios 201v and 292r showing figures drinking from a chalice.*

Opposite:
52. *Folio 100v, page from St Matthew's gospel with two lions drinking from a chalice.*

– show grapes (communion wine) being consumed. On other folios, like 258r, bunches of grapes are added to the text, perhaps 53 to celebrate the eucharist as the flourishing of the word. Chalices appear in the manuscript, as they do on Muiredach's cross at Monasterboice and on the market cross at Kells itself. In all, the book contains around forty chalices or clear chalice-forms. On folio 201v, a figure crouching above the name *abracham* drinks 50 from a chalice held in his right hand. Henry has argued that this represents Melchisedek, the priest who offered Abraham bread and wine after Abraham returned from defeating the four kings (Genesis 14.18). A similar figure at the top right of 292r drinks 51 from a goblet while facing an open-mouthed lion. On 100v, two 52 lions appear to drink from a chalice. A chalice with very styl-ised vine forms, again denoting eucharistic wine, make up a line-filler on folio 326r. Similar, more literal devices are dis-cussed below. Abstracted but unmistakable chalice and vine-scroll devices appear as line-fillers on 48v, 106v, 257r and 276v, while the motif is presented in an abstraction almost beyond recognition on folios 21r–22r.

Much valuable work has been done recently by Dr O'Reilly in elucidating hidden or implied eucharistic imagery in some of the major pages. She draws attention to the reference in the text of folio 113v to the institution of the eucharist: *Hoc est enim corpus meum . . . Hic est enim sanguis meus noui testamenti* ('This is my body . . . This is the blood of the new testament': Mt.

Sequitur at in cælo iurat in throno
di· & in eo qui sedet super eum

Uae uobis scribæ & pharissæi
hypucritæ quia decimatus mentã
& anetum & cyminum & reliquistis
quæ grauiora sunt legis iudicium
& missericordiam & fidem hæc opo [R]
tuit facere & illa non omittere ·:·

Duces cæci excolantes culicê ca
mellum autem glutientes ·:·

Uae uobis scribæ & pharissæi hy
puchritæ quia mundatis quod
deforis est calicis & perabsidis
intus uero pleni estis sunt rapiña
& inmunditia farisse cæce
munda prius quod intus est calicis
& perabsidis ut fiat & id quod de

53. *Detail of folio 258r, showing bunches of grapes at the ends of lines.*

Opposite:
54. *Folio 114r, the arrest of Christ.*

26.26–28), and suggests that the page facing it, folio 114r, is a depiction of this very phrase, as well as functioning on a direct level as an image of Christ's arrest. Its eucharistic content is confirmed by the plant forms emanating from vessels at Christ's head, which may be interpreted both as vines and as olives, and thus again as the name of Christ, 'the anointed one', Christ being identified with the olive tree or its fruit in exegetical literature. Significantly, the plants wind around the words at the top of 114r which refer to Christ's going with his disciples to the Mount of Olives following his last supper with them. The vessels resemble amphorae rather than communion goblets. Christ's arms and body take an attitude both of prayer and of the crucifixion to follow.[32]

Additional eucharistic symbolism is represented by the flabellum, which was used widely in the Eastern church to keep the altar clear of flies and other contaminants. In the more temperate climate of Ireland there was less need for it but it held a symbolic purpose as a defence against impurities. St Colum Cille's flabellum was revered as a relic until 1034, when it was lost overboard on the occasion of the drowning of Maicnia ua hUchtáin, lector of Kells, on a journey from Scotland.

Flabella are prominent in the Book of Kells on folios 27v and 129v, in the background of the evangelist symbols. Like surviving flabella from the east, they are represented with bells on their rims which made a melodious sound when shaken.[33]

54

5
38

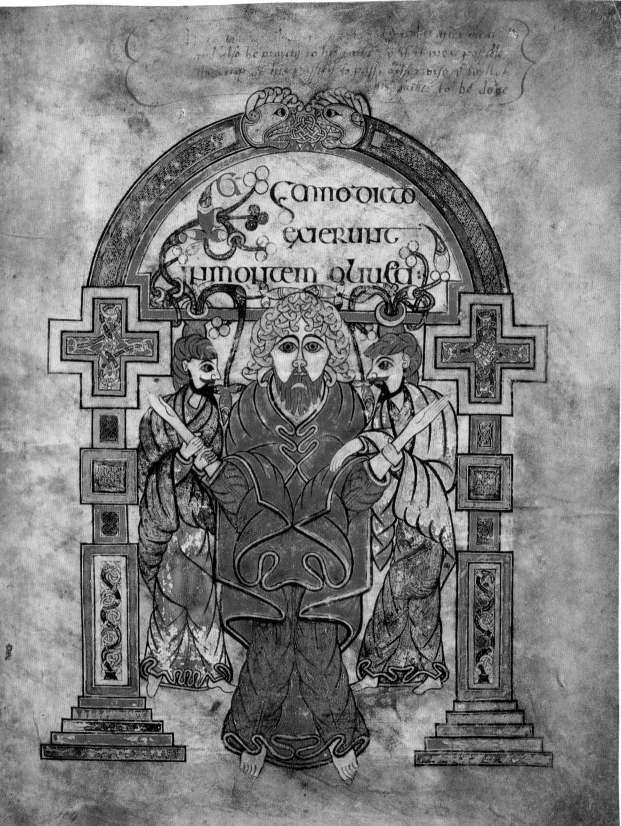

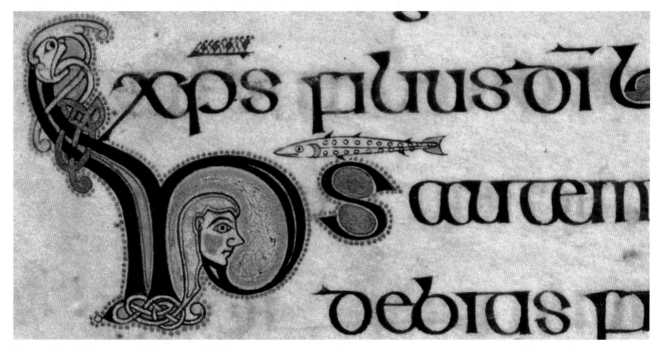

Christ and his symbols: fish, snake and lion

The face of Christ is constantly before the reader. At his nativity (folio 34r), he is placed symbolically both at the centre of the frenetic decoration of the page, and overlooking it. On other pages, Christ's face is often confirmed in its identity by the addition of other symbols, chiefly a fish. This is the case on folio 161v, and on 296r, at a point in the text where Christ throws the money changers out of the temple. Generally, he is presented as blond, youthful and radiant, as on 80v or 58v, where lions consume the fruit of the vine, which emanates from him. On 179v, the youthful Christ is shown with a fish and a lion. 55

Christ was identified and accompanied by a large number of different symbols, including the fish, the lion, the snake and the peacock. It is necessary to offer a brief explanation of these symbols. The fish was a symbol of Christ from the second century, having associations with the eucharist and with new converts, swimming in the waters of baptism. Exactly how the symbol was devised is not clear. The initial letters of the words 'Jesus Christ, Son of God, Saviour' form the Greek word for fish, *icthus*, but it is not known whether it was the acrostic or the symbol which came first. The fish is common in the Book of Kells, normally accompanying the face or name of Christ as a suprascript abbreviation bar. The species is like a salmon, and resembles the fish escutcheon from the Sutton Hoo burial site in East Anglia.[34]

55. Detail of folio 179v, showing the abbreviated form of the name Jesus (ihs̄), with the youthful Christ, a lion and a fish.

Opposite:
56. Folio 130r, the beginning of St Mark's gospel.

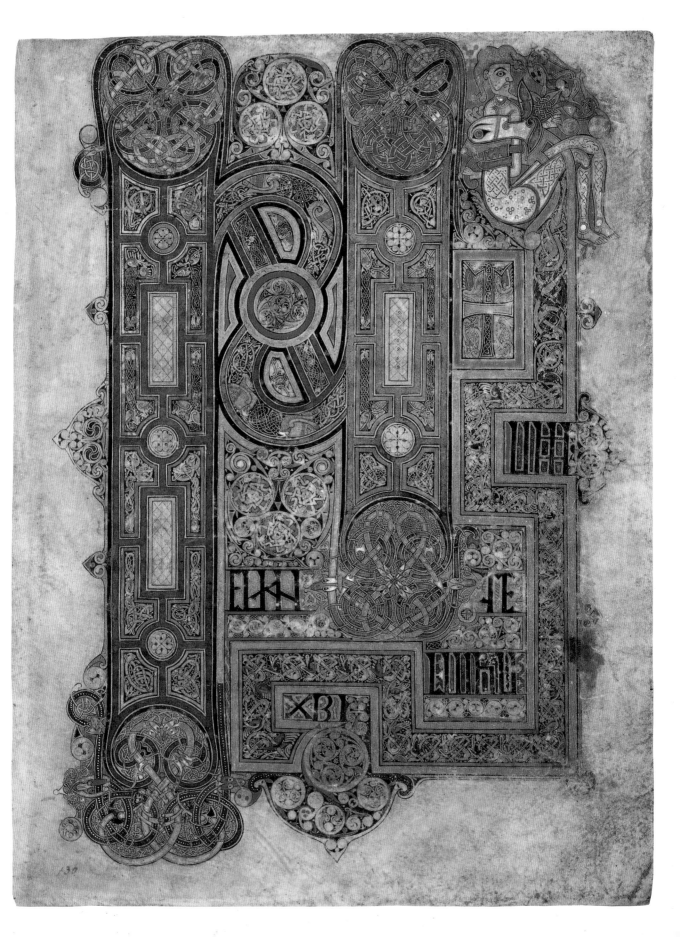

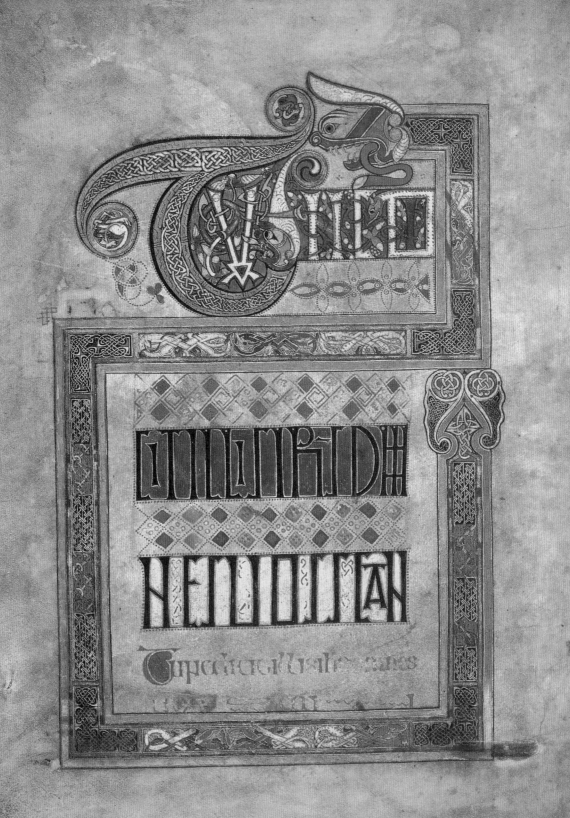

The snake was a symbol of Christ's resurrection, due to the belief that it renewed its youth when it shed its skin. It was used in this way in other media. On Muiredach's cross at Monasterboice, for example, snake ornament is associated with the crucifixion and other imagery of Christ's passion. But it also acted as a reminder of the fall of man, an embodiment of evil, the snake in Genesis being responsible for the loss of innocence. The snakes in the Book of Kells developed from abstract interlace and are highly stylised, with heads like those of ducks on folios 5v, 26r (where the shelduck particularly comes to mind), 130r, 184r, 241v, 260r among many others. Frequently they have the tails of fish. Snakes could form complete borders, as on 114v. On certain folios, like 104v, 107v and 274v, a single snake forms the initial letter *S*.[35]

The lion was another potent symbol of Christ's resurrection. According to the natural history contained in the fifth-century Greek text *Physiologus*, known in Ireland from the *Etymologiae* of Isidore of Seville, lion cubs were born dead, but on the third day were revived by their father's breathing on their faces or roaring. This was a striking metaphor for the revival of Christ three days after his death. There are many references in the Old Testament and in the mythology of other cultures to the majesty and power of lions, qualities which caused them to become associated with the royal house of Judah, from which Christ was descended, and with Christ himself.

The depiction of human heads in the mouths of beasts has a long tradition, going back to classical art. In a Christian context, it could be understood in a number of different ways. The image could recall Daniel and the lions, or Jonah and the whale, or Psalm 21.14, 'They have opened their mouths against me, as a lion ravening and roaring'.[36] Psalm 21.22 reads, 'Save me from the lion's mouth'.[37] It was probably this 'passion' psalm which the artist had in mind in employing fierce and roaring profile lions on folios 130r and 124r, the latter page carrying the text 'Then were crucified with him two thieves' (*Tunc crucifixerant Xpi cum eo duos latrones*). On the next opening (folio 125r) Jesus was said to have invoked the beginning of Psalm 21 in crying out ('My God My God why hast thou forsaken me?'). It is exactly on this line that Christ's face is displayed, his expression seeming to betray his distress.

A human figure between two lions could be an enactment of a phrase at the opening of the Old Latin version of the Canticle of Habakkuk, one of the Minor Prophets of the Old Testament, 'You will be revealed in the midst of two animals'.[38]

56
57

59

58. *Detail of folio 179r, with initial* P *made up of a cat, bird and snake, and another snake forming the* S.

59. *Detail of folio 125r, the face of Christ.*

Opposite:
57. *Folio 114v, (Mt 26. 31), Tunc dicit illis Iesus omnes uos scan[dalum].*

60. Detail of folio 111r, a lion.

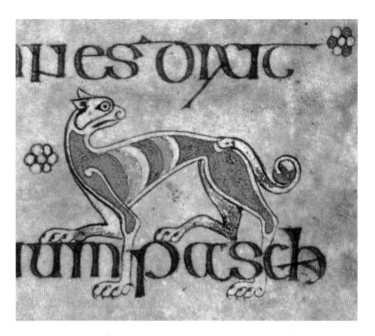

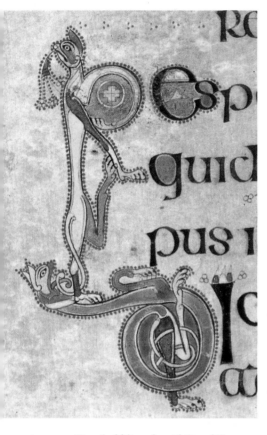

61. Detail of folio 258r, with R and D composed of two elongated lions.

This excited a great deal of exegetical comment. The animals were related to the two testaments, Old and New, and to events in the life of Christ: the transfiguration, where Christ was seen between Moses and Elijah; the crucifixion, where he was placed between the two thieves; and the arrest, where his captors were positioned on either side of him.[39] Dr Ó Carragáin has suggested convincingly that Habakkuk lies behind the image at the top of folio 2v, where the figure of Jesus is made known as Christ, literally between two beasts.[40] It may be too that echoes of Habakkuk occur in the placing of the host between two mice on folio 34r. 49

Lions occur throughout the manuscript on text pages, executed with particular elegance in the yellow *A* on 116v, or 258r, 61
with an *R* and a *D* composed of two elongated beasts. On 7v, 7
a lion acted as a finial to the Virgin's throne. On 28v, a pair of 35
lions was employed in the same context, functioning as a symbol of Christ as well as of the evangelist St Mark. While these profile heads derive from classical models and are clearly recognisable, the models and even the identity of the lions on the text pages are less certain. Normally however some if not every aspect of their depiction takes a leonine form, whether it is the hindquarters, as on 111r, or the mane of the lion on 212r. 60

Opposite:
62. Folio 124r, part of St Matthew's gospel, with roaring profile lions.

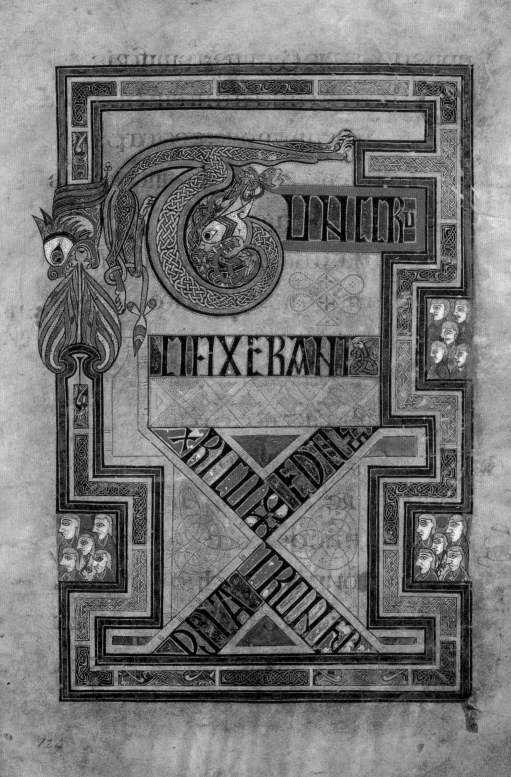

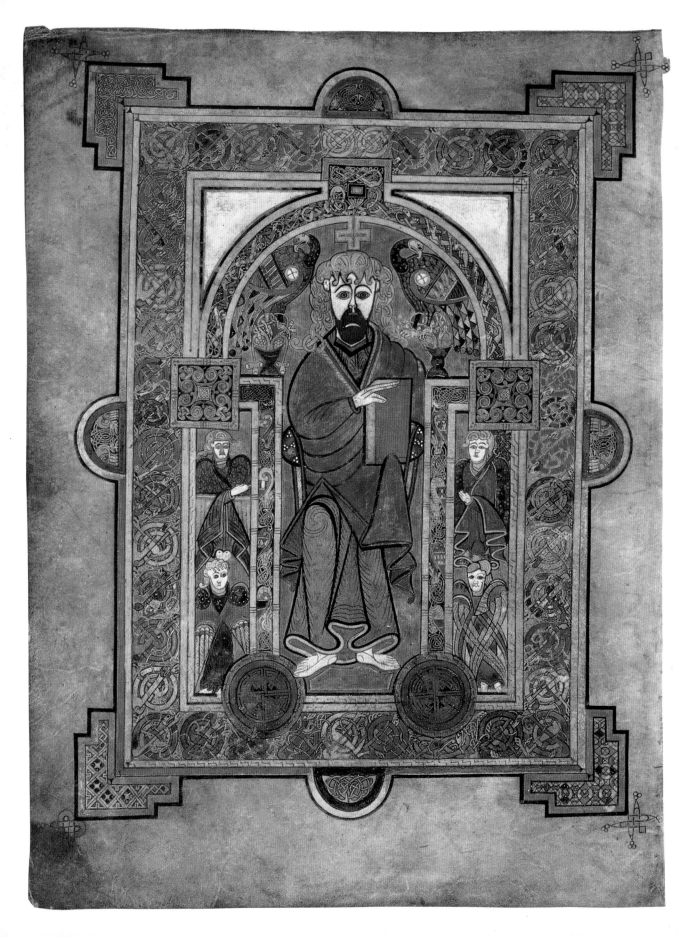

The peacock symbolised the incorruptibility of Christ because, again according to an ancient belief codified by Isidore, its flesh is so hard that it does not putrefy.[41] St Augustine of Hippo put this belief to the test. Served roast peacock at dinner in Carthage, he ordered that meat from the breast be put aside. After thirty days, he found that there was no bad smell. After a year, the peacock's flesh had become only a little desiccated.[42] Peacocks were used widely in different media in early Christian art. In a parallel to their use in the Book of Kells, they were employed in contorted shapes to form letters in seventh and eighth-century manuscripts from Luxeuil (now Wolfenbüttel, Herzog August Bibliothek Weissenburg 99, and Paris, Bibliothèque Nationale lat. 9427).[43] In a manuscript with Irish connections from Würzburg (Würzburg University Library M.p.th.f.69 folio 35v), a peacock forms part of the initial *P* of *Paulus*.[44]

The portrait on folio 32v is a key to the vocabulary of christological imagery, the artist seemingly wishing to leave no doubt as to the identity of his subject. A cross is placed above Christ's head, and he is flanked by angels, and by peacocks, their wings marked with eucharistic hosts. The feet of the peacocks are entangled in vine scrolls growing from chalices.[45] Vertical peacocks, eight in all, recur in the columns on either side of Christ on 32v, and two more are placed in each of the 'ears' which protrude from the centre of either side of the frame. These same symbols together – peacock, chalice, and vines – appear on many other pages, including the canon tables. On folio 2r, peacocks are drawn in the central column and in each of the four corners, one of the birds in the lower right corner consuming grapes. At the centre of the main arch of folio 2r, within the flanking pairs of peacocks, is an inverted chalice from which flowering vines emerge. At the top of folio 3r is a circular extension enclosing the head and shoulders of a figure which must be that of Christ. Below this extension, and encroaching on it, the top of the frame is composed of two lions facing each other, their tongues gripped in the mouths of peacocks. This echoes the facing page (folio 2v), where they are gripped by Christ.

The peacock and the dove

Above:
64. *Detail of folio 2r, the column of a canon table, showing peacocks (turned at right angles).*

65. *Detail of folio 2r, showing corner with peacock eating grapes.*

Opposite:
63. *Folio 32v, portrait of Christ.*

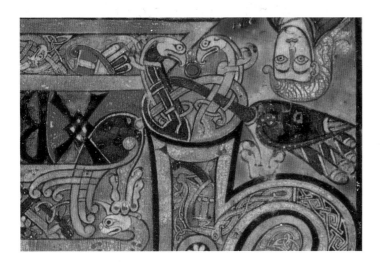

67, 68. *Two details from folio 8r, showing (left, picture inverted) two peacocks holding a disc between them, and (below) a chalice with sprouting vines.*

Between the peacocks – and the conjunction of imagery begins to seem unvarying – is a chalice which sprouts eucharistic vines. Peacocks surge across the arches of both 2v and 3r. They appear in the outer columns and in the capitals of those columns on folio 2v. They form a circle around the symbol of the evangelist Matthew on folio 3r and are at the base of the outer columns of that page. The opening 3v–4r has a similar set of motifs. On 4r, the symbols of the man and the eagle are flanked by chalices sprouting flowering vines (one of the vessels with the man substantially lost to abrasion), while the supporting columns are filled with peacocks, accompanied in the central columns by vines. It may be that the birds in evident conflict with warriors bearing shields and spears in the spandrels of folio 4r should be interpreted in terms of crucifixion imagery, the birds to be understood as peacocks and thus as Christ, and the spear as the weapon which pierced his side. These spandrels are a partial match of the two pairs of peacocks occupying the same position on 3v, where eucharistic hosts are tucked into each corner in an echo of the device employed on 32v.

On folio 8r, the band of decoration second from the foot of the page is composed of a central chalice from which vines are flowing. Between the first and second lines of text on that page, there is a similar motif, which has to be read horizontally, while two peacocks (which must be read upside down) stand facing each other below this line holding a disc between them (almost certainly a eucharistic host is intended), and accompanied by a horizontal band of another four peacocks. One of the peacocks on folio 8r is standing directly on the head of a snake. This is an iconographical parallel to a late eighthcentury ivory carving of Christ treading on beasts (GenoelsElderen Diptych, Musées Royaux d'Art et d'Histoire, Brussels), and to the fullpage

(Margin numbers: 66, 63, 68, 67)

Opposite:
66. Detail of folio 4a, a canon table, showing a man in combat with a peacock in the spandrel and in the arch a man (symbol of St Matthew) with a chalice sprouting vines.

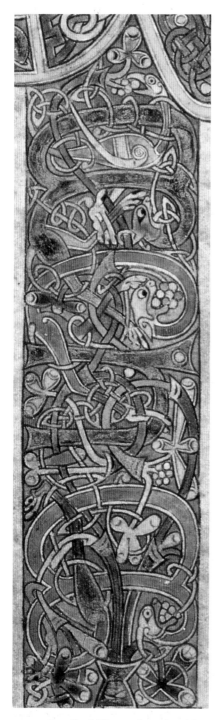

painting of king David standing on a double-headed snake in the eighth-century Durham Cassiodorus (Durham, Dean and Chapter Library B.II.30 folio 72v), reminding the observer of Psalm 90.13: 'Thou shalt walk upon the asp . . .'.

The decorated band of letters on folio 19v (*Zacha[riae]*) **69** ends with a chalice, again positioned horizontally, from which fruiting vines emanate. A peacock and three lions are intertwined and consume the grapes. Peacocks, vines and a chalice, once more depicted horizontally and on the right of the panel, reappear on folio 292r decorating the letters *RIN* of the opening **72** words of St John's gospel. On folio 34r, these familiar components appear in a position to which the eye is not naturally drawn, the chalice being upside down at the top of the bottom **73** panel on the far right of the page. On folio 27v, they appear in **5** the lower left and top right corners. Two small panels on either side of the framed evangelist symbols on folio 129v contain the **38** same elements, interspersed with individual panels of snakes and peacocks. At the end of the genealogy of Christ in St Luke's gospel, at the foot of folio 202r, there stands the blond **70** figure of Christ flanked by two frames of decoration containing a pair of peacocks on one side and a chalice with vines on the other. Confronting peacocks, again an allusion to the immortality of Christ, occur within the *U* of *Una* on folio 285r, a page **71** dealing with the prelude to the resurrection and the visit of the women to the tomb of Christ. Intertwined with the peacocks

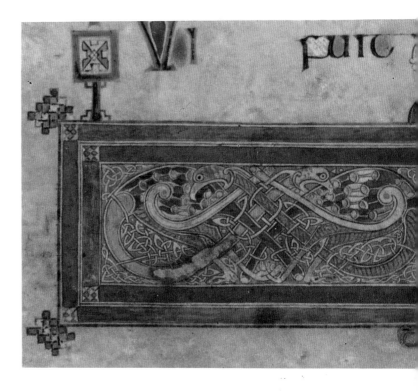

69,70. *Details of folio 19v (turned at right angles) and 202r, both showing chalices with sprouting vines.*

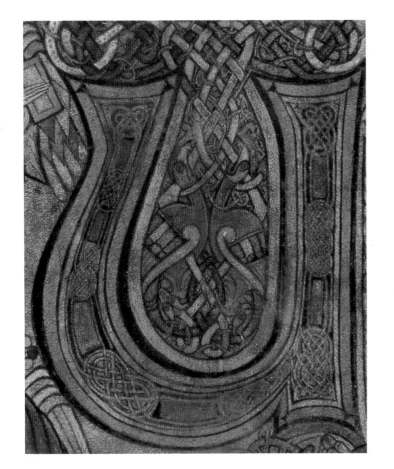

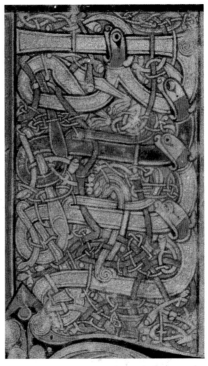

71. *Detail of folio 285r, confronting peacocks within the letter U.*

72. *Detail of folio 292r, turned at right angles, showing peacocks, vines and a chalice decorating the letters RIN.*

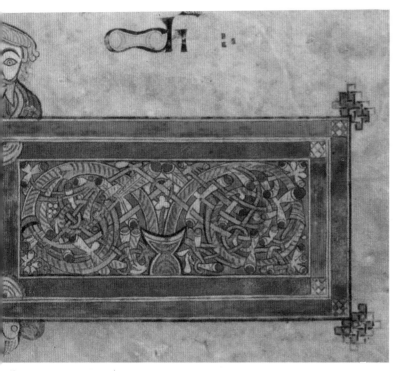

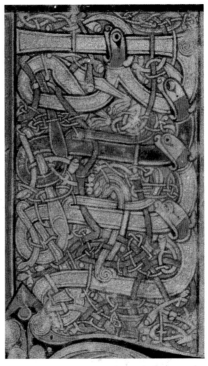

73. *Detail of bottom right-hand corner of folio 34r, inverted, showing chalice.*

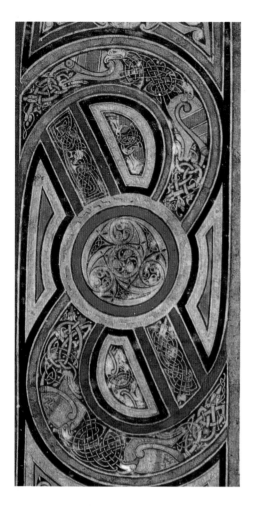

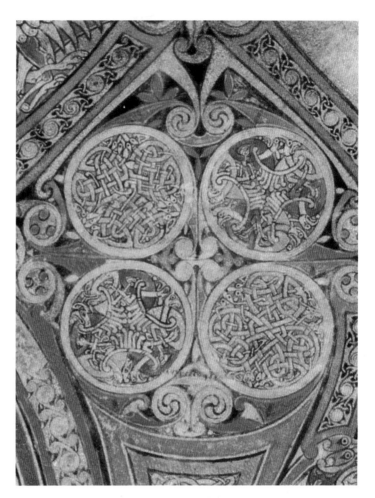

74. *Four birds, probably peacocks, from folio 130r.*

Above right:
75. *Detail of folio 29r showing peacocks (?) inside roundels.*

are snakes, the familiar and on this folio particularly appropriate motif of resurrection. The lion at the top right of the picture further recalls Christ. The frame is of lions consuming grapes which spill out of eucharistic chalices at the centre of each of the four sides.[46]

The pattern of decoration which so frequently places peacocks in conjunction with chalices and vines seems to provide grounds for recognising them in the majority of the birds in the manuscript. The initial letters and minor decoration of the text pages vary in the expertise of their execution, depending on the skill of the individual artist or the realism of his model, and can present confusingly as generalised quadrupeds or birds. If, however, the basic vocabulary of the initials is recognised as being composed of the lion, the snake, the eagle, and the peacock in varying combinations, it follows that the decoration has a clear programmatic intent, and the manuscript gains in accessibility, although it loses a degree of the whimsy which is part of its surface attraction. Once understood symbolically in

conjunction with each other, as they were by the artists, each motif could be presented in a realistic or in a more schematic manner, to form a recurring interplay of christological imagery, either in single instances too numerous to detail, or in varying and striking conjunctions with each other, as on folios 179r and 250v.

It is probably a peacock which is intended on folios such as 277r or 309r, where crest feathers are added. On 72r, a crest is added to what resembles a plump game-bird. In other places, like folios 256r, 271r and 280v, there are attempts to render the ocellus or 'eye' of the tail feathers. The length of the tail is emphasised in most drawings, whether it is up, as it is on 104v, or down, as it is on pages such as 54r, where the bird is draped languidly over the first stroke of an initial *H*. Some indications are made, on 278r and 279r, of the tail feathers in display, though they are imperfectly executed perhaps because the model was not fully understood. The peacock form becomes particularly stylised in groups of more than two, as in the interlace down the side of 200v, or centre left near the top of folio 130r (*Initium*, the opening word of St Mark's gospel) helping to form the bar of the *N*, and in most of the panels of that page. The sharp-eyed observer can catch sight of what fittingly are known in their collective sense as ostentations of peacocks in certain of the major pages, such as folio 29r, where they gather in roundels at the top of the *L* of *Liber*. At least twenty-four of them are on folio 8r, and over fifty on folio 33r, where, as on the Chi Rho page (34r), they mingle with the resurrection motif of the snake. They are unfinished on folio 30v. On 200r, they are interlaced with highly stylized lions. Peacocks are again to be found, sometimes in the company of snakes, in the decorative details of the elaborated text pages: in the shaft of the *I* of the *In principio* page at the opening of St John's gospel (292r); within the body of the beasts in the frame of 187v; and squeezed into panels on 124r. Peacocks are drawn quite crudely in the framing panels of 203r, and in the decorated band of lettering on 12r, more expertly in similar bands on 13r, 15v (a small device), 16v, and 18r, and in a very stylised way in 188r. The only major page from which they are missing is 114v. The Book of Kells is not alone in its stylised representation of peacocks. In the Trier gospels folio 173r (Trier Domschatz 61), for example, a peacock forms a long initial *I*.[47] Here it is hard to escape the impression that the artist had almost forgotten the species of bird he was attempting to draw.

Adomnán commented that 'often in sacred books a dove is understood to signify mystically the Holy Spirit'.[48] This is not

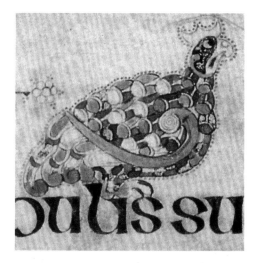

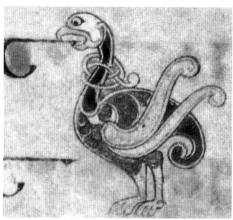

76, 77. *Possible peacock (top, from folio 72r) and probable dove (bottom, from folio 201r).*

78. *Detail of folio 200r, bearded warrior with spear and shield.*

Opposite:
79. *Detail of folio 250v, part of St Luke's gospel.*

only a rare explanation of a programme of decoration, but also suggests Adomnán's familiarity with decorated manuscripts. One example, from sixth-century Italy, is in Paris, Bibliothèque Nationale, lat. 2769 folio 23v,[49] where birds resembling collared doves appear. In the early medieval church the pyx (a store for eucharistic hosts) could take the form of a suspended metal dove, an allusion made in the mass of the late eighth-century Stowe Missal.[50] The birds on folio 201r of the Book of Kells 77 might carry an association with doves through the connotations of St Colum Cille's name in religion, 'Columba', which is Latin for dove.[51] According to the preface to Adomnán's life, 'So good and great a name is believed not to have been put upon the man of God without divine dispensation. According to the truth of the gospels, moreover, the Holy Spirit is shown to have descended upon the only-begotten son of the eternal Father in the form of that little bird that is called a dove'. It cannot be said, however, that any of the birds in the Book of Kells are natural-istic depictions of doves.

Several problems remain in schematising the decoration. Almost invariably, in even the most modest decoration, lions in the Book of Kells are depicted with sprays of foliage or elongated tongues emerging from their mouths. The spray of foliage prob-ably derives from the olive branch brought by the dove of Genesis 8.11 to Noah in the ark. Frequently, human faces have strands in their mouths, as on folio 53v. The motif was a common one in manuscript decoration, appearing, for example, in a mid eighth-century manuscript from Bobbio (now Milan, Biblioteca Ambrosiana, B.159 sup.) where it takes the form of an exaggerated tongue or trumpet shape.[52] A double trumpet is in the mouth of a face in another eighth-century manuscript which belonged to Bobbio (Milan, Biblioteca Ambrosiana, C.98 inf. folio 17r).[53] It is not clear why the device should be so common, or what it signifies, though it would be generally consistent with other decoration if it were to indicate a celebration of or allusion to the flourishing or declaiming of the word of God. Other, more obscure references to Christ perhaps await interpretation. A bearded warrior is placed at the opening of the Lucan genealogies on 200r. He 78 carries a shield in his left hand and a spear in his right hand. Beneath the shaft of the spear, and in parallel, his genitalia are drawn in ink and outlined with red dotting, some of which has been abraded. This may allude, on a page dealing with the genealogy of Christ, both to procreation and to death, the spear of the warrior prefiguring the crucifixion.

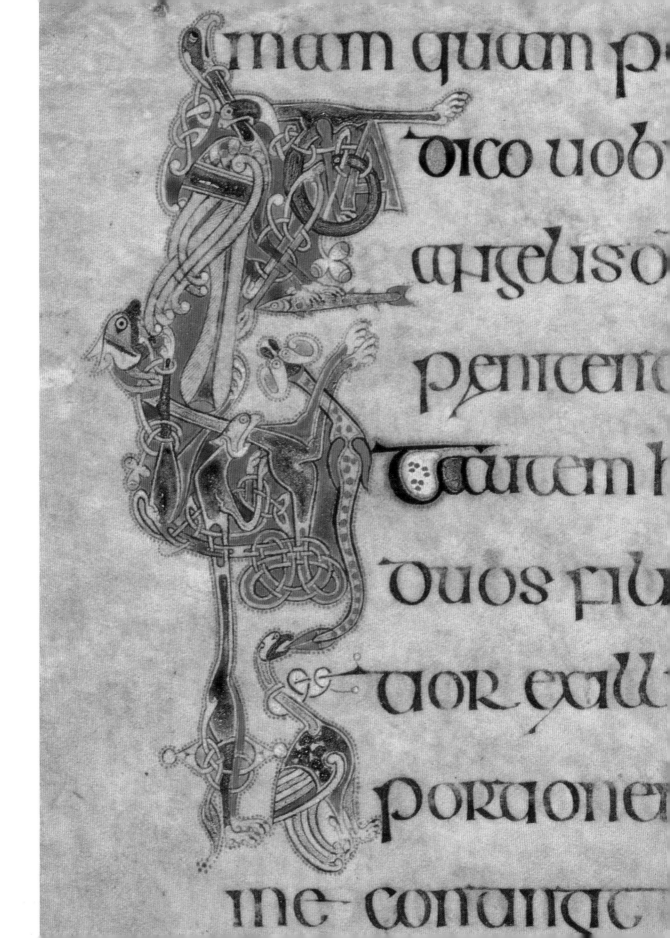

nam quam p̄...

dico uob̄...

angelis d̄...

penicen...

trautem h...

duos filu...

uor call...

porttonem...

me contiug...

Illustrative features in the minor decoration

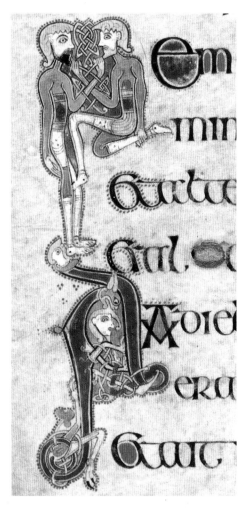

Although the drawings do not have a directly illustrative function in the modern sense, some of them refer, albeit in an oblique way, to passages in the text. Attention has frequently been drawn to two examples in particular. A cock and two hens tread the ground on folio 67r, just above the opening of the parable of the seed and the sower (Mt. 13.17–22). Françoise Henry remarked that the figure lurking within the initial *U* on the line below may, additionally, represent the 'wicked one' (*malignus*) who interferes with the seed.[54] At the text '*Nemo seruus potest duobus dominis seruire . . .* ' (no servant can serve two masters': Lk. 16.13) on folio 253v, the artist has formed the initial *N* from two men grappling and tugging each other's beards. While beard-pulling is a common image in the Book of Kells, and generally in insular art, in this case it might appear to illustrate the two masters.

It is possible to detect an illustrative intent behind other features of the minor decoration. If, for example, the bird on folio 96r is a peacock, the hands around its throat may be those of the Pharisees, who are attempting to ensnare Christ (Mt. 22.15). The depiction of conflict may be regarded as doubly appropriate at this point, immediately after the parable of the guest who was cast into the outer darkness for refusing to wear a wedding garment. It may however be mistaken to interpret the scene as one of conflict, if the figure is that of Christ himself, his hands clutching one of his symbols. A parallel occurs in a manuscript from north Italy written in the second half of the eighth century (Novara, Biblioteca Capitolare 2 (LXXXIV) folio 43r), in which

82

80

81

80. *Two initials from folio 253v, the upper N made up of two grappling men.*

81. *Initial from folio 96r, formed by a man strangling a bird.*

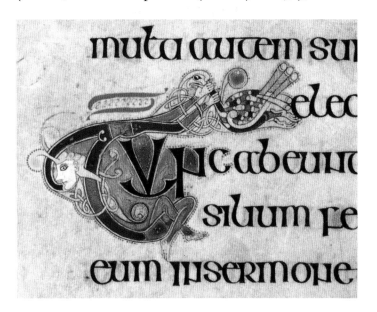

![Illuminated manuscript text with decorative initials and bird figures]

a disembodied hand reaches out to clutch the neck of a peacock carrying a strand of foliage (an olive branch?) in its beak.[55] The imagery may be paralleled in several places in the Gellone sacramentary (Paris, Bibliothèque Nationale lat. 12048), such as folio 99v, where a disembodied hand reaches out to harpoon a fish, or 33r[56], where a hand clutches a snake. Other references to conflict, more specifically to choking, appear in the gospels. On folio 84r, the parable is told of the servant whose master forgave him the large sum of ten thousand talents, but who straightaway fell on a fellow servant who owed him the meagre sum of one hundred denarii, grabbed him by the throat and demanded restitution (*tenens suffucabat eum dicens redde quod debes.* Mt 18.28). Such a text might seem to present striking artistic possibilities of the type employed on folio 96r, but the page is wholly devoid of animated decoration. Two small men appear on folio 44r, the first human figures for several pages. Both may illustrate their duty to their neighbours as urged in the Sermon on the Mount. On folio 53v, a contorted man sticks out his tongue, at the point where Christ asks if the healthy need a doctor as much as the sick do (Mt. 9.12). On folio 68v, a man with a mouthful of teeth (one of the few men in the book with teeth, 335v being another) and an exaggerated lock of his hair in his mouth forms the opening letter of the verse *Haec omnia locutus est ihs̄ in parabulis ad turbas* ('All these things Jesus spoke in parables to the multitudes': Mt. 13.34). It is tempting to suppose that the verse may have inspired the form of the initial.

Many passages which pass unnoticed by the artists might appear to be suitable for illustration, using a repertoire with which the artist was familiar. Françoise Henry remarked that

82. *Cock and hens, from folio 67r.*

83. *Initial H from folio 68v.*

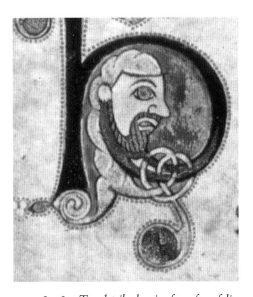

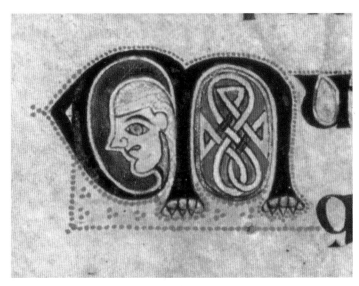

84, 85. Two details showing faces, from folio 309r, the first possibly God the Father, the second Christ.

Human figures and activities

vine ornament, so common throughout the manuscript, does not appear in places where the text mentions wine. At folios 56v–57r, the apostles are exhorted by Christ to be as wise as serpents and as simple as doves (Mt. 10.16). The artist has drawn lithe, contorted snakes at this point on both folios adjacent to the word *serpentes*, but no doves, or birds of any kind, are depicted. On folio 258r the phrase *congregabuntur aquile* appears ('[wheresoever the body shall be, thither] will the eagles also be gathered together': Lk. 17.37), but it is not accompanied by eagles. At folio 76r it might have been felt appropriate to allow fish to illustrate the telling of the miracle of the loaves and fishes (Mt. 15) but none is drawn. Examples such as these emphasise that the programme of decoration generally served a symbolic rather than an illustrative purpose.

On 309r, two faces are drawn inside initial letters. The lower face conforms to the type of the youthful Christ, but the other 85 face is more mature, with a dark beard, and represents God the 84 Father, at the beginning of the line in which Christ declares *Haec est autem uoluntas eius qui misit me pateris . . .* ('This is the will of the father who sent me': Jn. 6.38). Similarly, the face with the long beard on folio 294r is surely that of John the Baptist, at the 86 beginning of the line which explains his activities in Bethania beyond the Jordan. Some uncertainties remain, such as the face on 182r, whose short hair with tonsure or skull cap seems to rule 87 out an identification with Christ. Perhaps a monk is intended here. The panels of profile faces on folios 7v, 124r and 202v are 6,88 difficult to interpret. It has been suggested by Dr Alexander

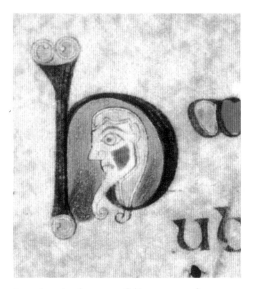

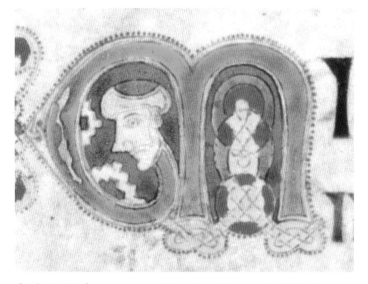

7
89
that the six faces on folio 7v may be ancestors of Christ.[57] The similar profile figures in three frames on folio 124r have not satisfactorily been explained. Seeming to have an ecclesiastical appearance, they gaze over to the blank page which is now folio 123v but which was reserved for a scene of the crucifixion. Each frame contains five figures, of whom two wear purple cloaks, two wear red, and one wears a robe of a mustard shade. A disc, the meaning of which is not clear, is placed between the heads of the top figures in each frame, and red discs appear on the cloaks of six of the figures. There are thirty-four faces on 202v. Placed after the Lucan genealogies, they may also be ancestors of Christ, or, as Dr O'Reilly has suggested, depict the faithful who make up the body of the church, representing this idea in an almost literal style.[58]

86, 87. *Faces from folios 294r (probably John the Baptist) and 182r (possibly a monk).*

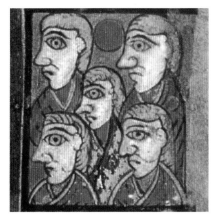

88, 89. *Panels of profile faces from folios 7v and 124r.*

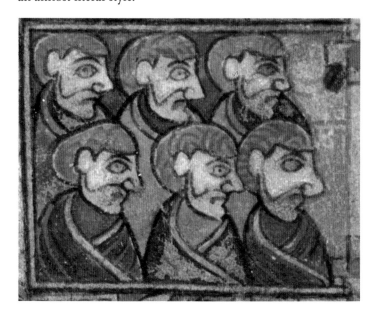

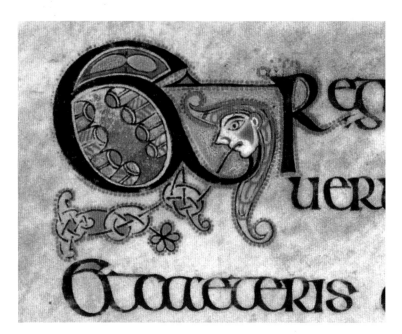

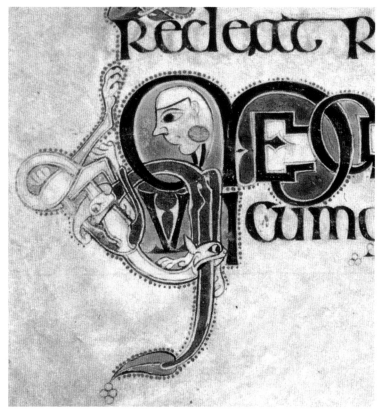

90, 91, 92. *Three details showing faces of women, folios 97v, 286r and 257v (possibly Lot's wife).*

It is possible that women appear in the manuscript in addi-
7,90 tion to the major image of the Virgin on 7v. On 97v, for
example, two entangled figures compose the initial *P* of
Pharissei. While the upright figure is a man, the cross-figure has
92 the appearance of a woman. On 257v, it may be Lot's wife who
is represented at the beginning of the line *Memores estote uxoris lot*
('Remember Lot's wife': Lk. 17.32). It is again a feminine face,
91 on folio 286r, which seems to illustrate the account of the return
from the sepulchre of the women who had come with Christ
from Galilee (Lk. 24.9). The angels may be judged to have a
feminine appearance, consistent with this episode, on folio 285r
and on the Virgin and Child page.

Human activities abound. Images of soldiers or warriors
appear on folios 114r, 200r and 4r in contexts to which allusion
has been made above. It is more difficult to find a textual or sym-
bolic context for the seated man with a shield who appears to be
in the act of throwing a spear on folio 99v. Thirty figures, as well
as one uncompleted, are engaged in various activities around the
letters which form the opening word of St Luke's gospel,
94,95 *Quoniam*, on folio 188r, a page which to date has defied satisfac-
tory analysis. Françoise Henry felt that it presented an image of
hell's torments, and the figures with their heads in the mouths of
lions may justify this interpretation. It has also been taken as an
illustration of *multi* ('many'), the second word of the following
93 page, 188v. Four pairs of men sit at the top centre at the right of
the page, their legs entangled as interlace and pulling each
other's beards. A similar image occurs on the market cross at
Kells, while the figures represented back-to-back in this part of
the page are similar in pose to those in two manuscripts with
close Irish connections in continental Europe, Turin, Biblioteca
Nazionale MS O.IV.20 folio 129r and St Gallen MS 1395 p 422.
In another vignette, one man ladles wine, in a flow of an
appropriate burgundy shade, into a goblet held by another man.
The general tenor of the activity around them does not lend itself
to an ecclesiastical or liturgical interpretation, and it may be –
though this is purely conjectural – that a parody of the euchar-
ist is being enacted. The figure slumped against the left side of
the frame may be suffering after-effects from the wine. Two
figures hold their heads within the mouths of lions, in what
seems a parallel to a detail in a late eighth- or ninth-century
Anglo-Saxon ivory carving of the Last Judgement (London,
Victoria and Albert Museum 253: 1867). Three other figures
hang as though on a cross, most obviously the figure whose
trunk is draped across the near side of the *I*. The entwined arms

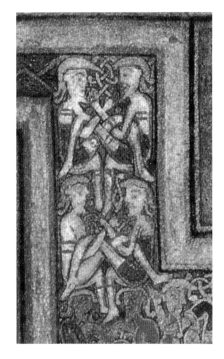

*93. Men pulling each other's beards, detail of
folio 188r.*

94, 95. *Folio 188r, the opening of St Luke's gospel* (Quoniam)*, with detail (below) showing enigmatic figures bottom right.*

of the two men facing each other within the second arch of *M* may be simply an artistic device parallel to the more common interlacing of legs. The arms seem, alternatively, to be in such an attitude as to confirm the necessity for the prohibitions which were enacted in the Irish penitentials against homosexual practices.[59]

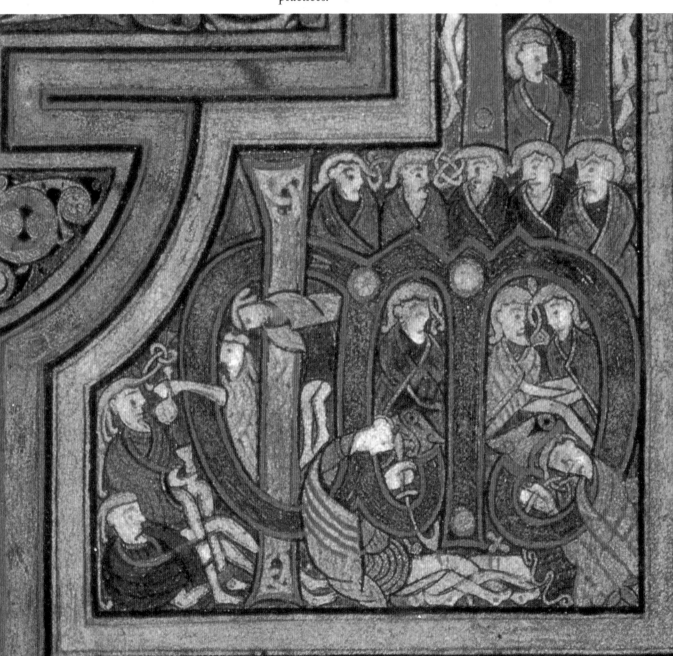

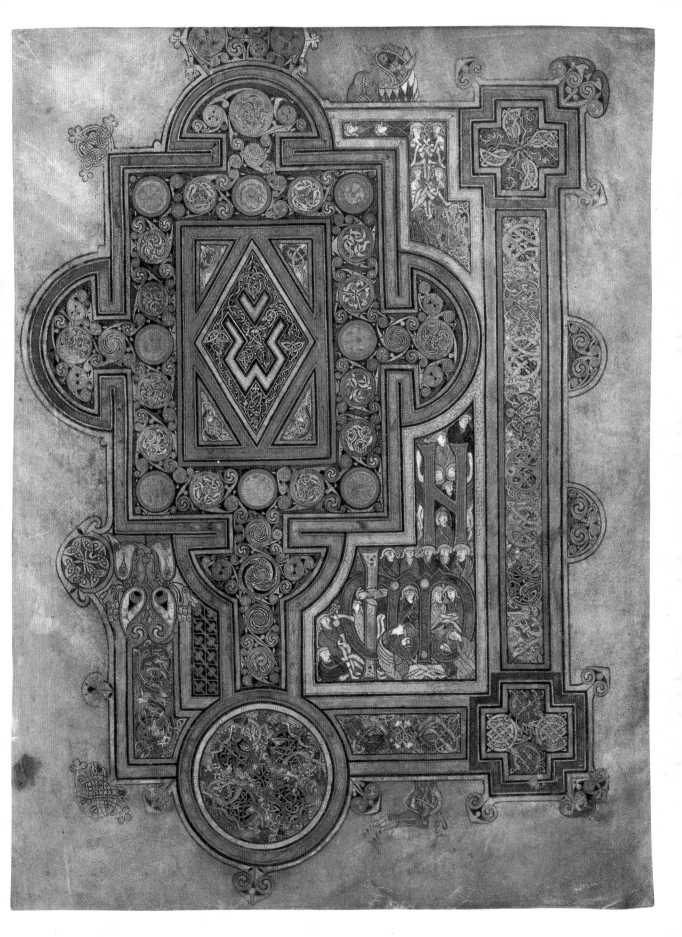

Minor animal decoration

96. *Horseman with foot extended, detail of folio 89r.*

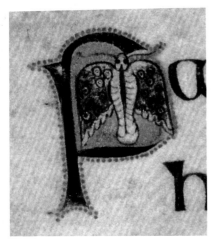

97. *Moth in initial P, detail of folio 63r.*

Some of the decoration of the Book of Kells acted as a novel form of punctuation. On folio 89r, a horseman's foot elegantly draws attention to an essential piece of Christian doctrine: *Et tertia die resurget* ('and the third day he shall rise again': Mt 20.19). A similar horse and rider on folio 255v seem, however, to reveal no purpose as they ride off the page; no purpose, that is, beyond serving to demonstrate the virtuosity and wit of an artist who could extend the serif of the final minim of the *m* of *unum* to form the tonsure of the rider.

 The interlinear animals mostly stand outside the programme of established symbolism and may be regarded as additions of an ornamental nature which demonstrate the range of models available to the artists and their proximity to nature. Many of the animals, like those on folio 34r, are native species. The otter and fish, the moths, and the cats and mice play a symbolic role in that page, but have been observed in quite a naturalistic way, as have the cock and hens on 67r. A hound is shown catching a hare on 48r, while another hare is on 131r. There is a beautifully observed moth on 63r, and a she-goat on 41v. On 72r there is a lizard, which might be native. There may be a sheep on 50v, though it is more likely that a cat is intended. Several convincing domestic cats, which were probably common in the monasteries, lie around watchfully on folios 280r, 329v, and 272r. Perhaps oddly, given their importance to the monastic economy, the domestic scene is not completed by

96

98

49

82

99,100

97

103,10

101

102,10

98. *Horse and rider, detail of folio 255v.*

99, 100. *Two hares, details of folios 48r and
131r.*

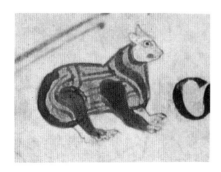

101, 102, 103. *Two cats, from folios 50v and 28or, and a she-goat, folio 41v.*

104. *Lizard, folio 72r.*

cows or calves, apart from the stylised versions of the evangelist symbols. A wolf, with joint articulation similar to the beasts of the Pictish stones, and with a fanciful arrow-tip added to its tail in the sixteenth century by Gerald Plunket, pads inconsequentially through the text of 76v. On 302r, there is a stag with joint articulation of the same kind. This has not previously been commented on, perhaps because its colouring, like that of the rest of the page, was left uncompleted. The stag is on its hind legs, its front legs raised and tucked in under its belly. Its antlers are laid

105, 106. *Stag (folio 302r) and cat (329v).*

back in a style which resembles a stag on the north side of the pillar at Tybroughney (otherwise Tibberaghny), county Kilkenny, dated in the early ninth century. It has prominent genitalia, as have many of the animals in the book, such as the lions on 34r, 19v and 178v, or the hound on 48r. There is a general stylistic resemblance to stags on the north face of the market cross and the east face of the cross of Saints Patrick and Columba at Kells, which may have been erected around the same time that the book was produced. Like the wolf, it is not clear why the stag is in the book. References to the stag occur in the *Physiologus*, where it stands for Christ in confronting the devil in the guise of a serpent. In a play on eucharistic imagery, the stag drinks water to counteract the venom of the serpent, but no snake appears on 302r, or on its facing page.

There is a scattering of exotic and fanciful creatures. An elongated bird with two sets of wings is on 177v. A similar drawing of a man with a fish's tail and fins is on 213r. Foetal-like quadrupeds, not conforming to any of the customary lion types, are in two circles at the top of the *B* of folio 29r. Griffins, legendary creatures with the head and wings of an eagle and the body and paws of a lion, may be intended on folio 45r, forming part of the painted final *s* of *hominibus* on the first line, and in the panel with the letters *IT* on folio 130r, though on these pages the hindquarters are not shown. In Christian imagery, the griffin could stand for two of the evangelist symbols and carry an association with the two forms of the eucharist, bread and wine.[60]

25

107

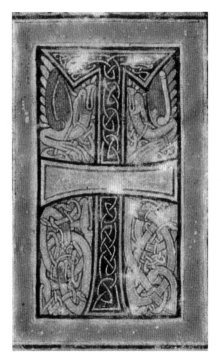

107. *Griffins (?) on folio 130r.*

Scribes and artists

Françoise Henry detected the work of three major artists in the book. She termed the first and greatest of these the 'goldsmith', because his use of yellow and silvery blue, coupled with the fine and detailed nature of his draughtsmanship, were suggestive of metalwork. This artist was, she felt, responsible for the eight-circle cross page (33r), for the Chi Rho page (34r), for the top section of the page of canon tables on 5r, and for the opening words of the gospels on 29r (*Liber*), 130r (*Initium*), 292r (*In principio*) but not for 188r (*Quoniam*). The 'illustrator' painted the temptation page (202v), the arrest of Christ (114r), the Virgin (7v) and perhaps the page of evangelist symbols preceding St John's gospel (290v). He may also have had some part in the *Natiuitas* page (8r). The 'portrait painter' produced the images of Christ (32v), of St Matthew (28v) and of St John (291v), and perhaps painted the symbols page for St Matthew's gospel (27v).[61] William O'Sullivan preferred to see the latter two as a single artist.[62] Jonathan Alexander differed further from Henry, and proposed a division of the book between two principal artists, the first responsible for 32v, 33r, 34r and perhaps for 130r, and the other responsible for 7v–8r, 28v, 29r, 114r, 291v–292r. Alexander remained in doubt about 202v and 290v, which he felt might be by the first artist, and was inclined to attribute 27v, 129v and 188r, along with most of the canon tables, to the second artist. Henry and Alexander both emphasised the uncertainty surrounding their attributions, and the collaborative nature of the artists' work.

More than one hand was responsible for several of the pages and stylistic changes are not easy to detect. On folio 8r, for example, two roundels at the lower left of the page seem to be additions in the style of the 33r and 34r artist, who is surely the artist also of folio 29r. It is remarkable that so few scholars have committed themselves, however tentatively, to the question of the artists, and to the allied problem of the number of scribes who worked on the manuscript. Henry identified three major scribes and termed them, in an unmemorable way, A, B and C.[63] To these three should be added a fourth major scribe, whom there is no option but to term 'D'.[64] All four scribes were clearly products of the same scriptorium, with few obvious differences between them in letter forms. All had a fondness for ending a line of text on the line above for decorative effect and to make use of space. Later Irish scribes termed this device, which can be seen on many pages, such as 131r and 309r, 'turn-in-the-path' (*cor fa casam*) or 'head-under-wing' (*ceann fa eite*). Scribe A can be characterised as having a conservative, sober hand with

8

26, 27

25

108

Opposite:
108. *Folio 309r, a page by scribe A. Lines 3 and 4 show the device known as 'turn-in-the-path' or 'head-under-wing' where a line of script is continued on the line above rather than below.*

Omne quod dat mihi pater ad me
ueniet · et eum qui uenit ad me non eiciam
foras ·:· quia descendi de caelo non ut faciam
sed uoluntatem eius qui me misit ·:· voluntatem meam
Haec est autem uoluntas eius qui m
sit me patris ut omne quod dedit
mihi non perdam ex eo sed resuscitem
illum in nouissimo die · Haec est enim
uoluntas patris mei qui misit me ut om
nis qui uidet filium et credit in eum ha
beat uitam aeternam et resuscitabo
eum in nouissimo die ·:·
Murmurabant ergo iudaei de illo
quia dixisset · Ego sum panis qui de
caelo discendi et dicebant nonne hic
est iħs filius ioseph cuius nos nouimus
patrem et matrem quomodo ergo dicit ·

309

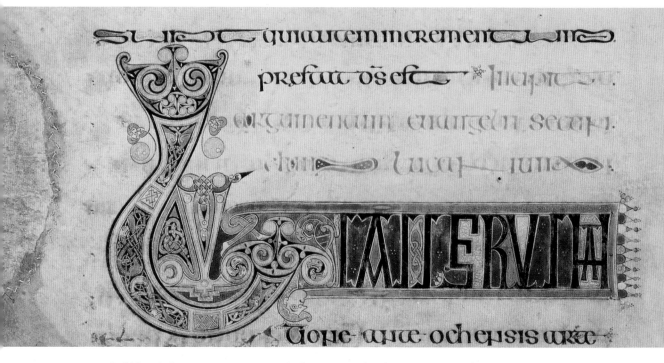

109. *Detail of folio 16v, lines 1, 2 and 6 by scribe A, lines 2 (end), 3, 4 and 5 by scribe B.*

Opposite:
110. *Detail of folio 48r, by scribe C.*

111. *Detail of folio 104r, by scribe D.*

Overleaf:

112, 113. *Folios 182v and 183r, facing pages in the original. On the right-hand page, after* Erat autem hora tercia *('Now it was the third hour' – Mk 15.25), scribe B gratuitously added* Et crucifigentes eum diuise[runt] *('And when they crucified him, they divided [his garments]'), from the facing page.*

little instinct for decoration. He began the preliminary texts, began and completed St John's gospel, and began St Mark's gospel (folios 1r, 8v–19v, 130v–140v, 292v–339v). Scribe B was aptly characterised by Françoise Henry as an 'extrovert', with a fondness for using coloured inks and completing his page with a flourished endline in minuscule. Scribe B completed the canon tables, the preliminaries and St Matthew's gospel (folios 1v–6r, 20r–26v, 125v–129r). In addition, he supplied rubrics and other additions on pages throughout the manuscript. Not all of these made sense. On folio 183r, for example, he intruded the words *Et crucifigentes eum diuise[runt]* in a space near the foot of the page, duplicating the line from the corresponding place on the facing page. Between them, scribes C and D copied the bulk of Matthew, Mark and Luke in a manner which combined the writing of the page with its decoration. Pages like 48r, executed by scribe C, or 104r, the work of scribe D, seem to demonstrate that the same person was responsible for the script, the initials and the interlinear decoration of the page. This leads naturally to the conclusion that scribe and artist did not necessarily perform separate functions in the manuscript. Scribe B seems to have been the latest of the scribes, since much of his contribution involved the completion of sections of the text. He may have been responsible for some of the work attributed to Françoise Henry's 'goldsmith', though many uncertainties attend this area of the study of the manuscript.

109

113

112

110
111

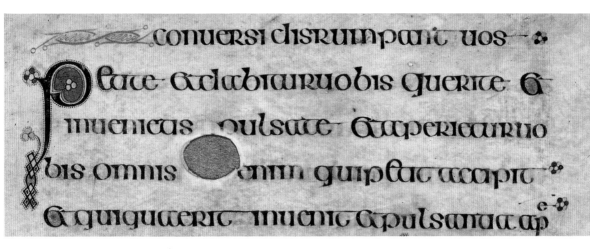

conuersi disrumpant uos

Petite et dabitur uobis querite et

inuenietis pulsate et aperietur uo

bis omnis enim qui petit accipit

et qui querit inuenit et pulsanti ap

Te autem praegnantabus et

nutriantabus in illis diebus

Orate autem ut non fiat fuga

uestra hime uel sabbato

Erit enim tunc tribulatio magna

qualis non fuit ab initio mun

di usque modo neque fiet

Et nisi breuiata fuissent dies

illi non fiera salua om

nis caro sed propter electos bre

uiabuntur dies illi

Tunc siquis uobis dixerit ecce

hic xps aut illic nolite credere

uerunt illum purpura Etinduerunt

eum uesamentis suis

Educunt illum uccruapfi

rent eum Etangarisaue

runt praetereuntem quendam

simonem cyrineum uenientem de

uilla patrem alexandri Etrufi

uttollera crucem eius

Perducunt illum ingolgo

tha locum quod est inter

praetatum caluariae locus

Dabant ei bibere murra

tum uinum Etnoncapit

Crucifigentes eum diuise

runt uesamenta eius mit

tentes sortem supereis quis quid

tollera

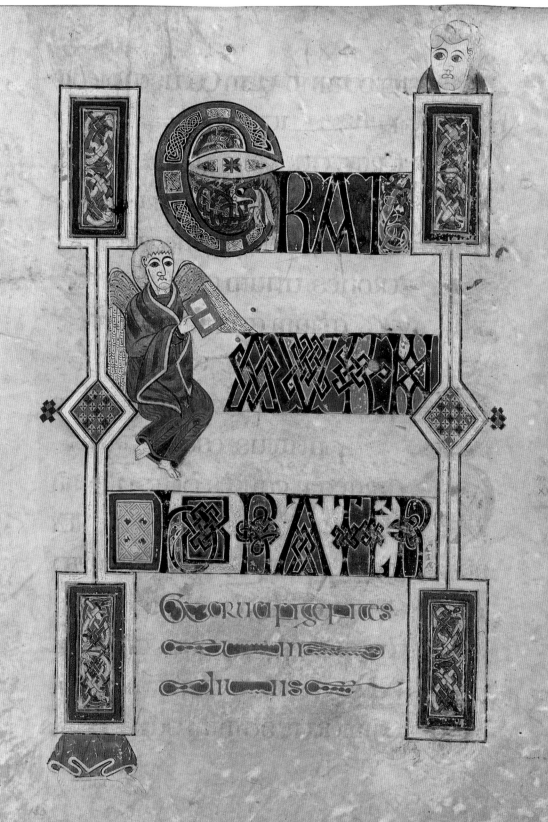

ipseautem actui

114. *Detail of folio 210r, where the word* autem *has been cancelled by inserting dots within the letters.*

There are several indications in the manuscript of correcting scribes, though it is not clear how many there were, or over what period they were at work. Most conspicuously, the copying of 218v was repeated by mistake, and the page subsequently cancelled for the reader by the addition of red crosses around and within the text. This may have been the work of scribe B. On 253v, several obvious changes were made. Most corrections were made more discreetly, the normal method being to insert neat dots within letters to be deleted. This can be seen in the word *autem* on the top line of folio 210r. In several places, additions were made to the decoration. On folio 309r, for example, some flourishing in red and green was added over punctuation dots at line 3, and it was probably at the same time that a crest was added to the peacock on that line. Several unexplained features remain. On 183r, for example, the letters *CIA* of the word *TERCIA* are scraped out of the yellow ground after the R. It is not clear whether this was done by the original scribe, or by scribe B or at an even later stage.

115. *Detail of folio 309r, where red and green flourishes are added to the punctuation in the middle line and a crest to the peacock.*

To produce a manuscript like the Book of Kells was tradition-ally believed to have been an extremely lengthy process. Recent consideration of the question has tended to favour the idea that proficiency in craft work normally goes hand-in-hand with speed. The evidence of two contemporary calligraphers is instructive. Timothy O'Neill took thirty minutes to copy the twenty-five lines of folio 28v from the Book of Durrow, and esti-mated that the whole of the text of that book could be copied in sixty days if the scribe put in six hours every day.[65] This was an optimum estimate which assumed good weather. On the requirements of decoration, there is the evidence of Mark Van Stone, who took roughly 120 hours spread over eight days to produce two decorated pages employing insular motifs.[66] While his work is not nearly as elaborate as the Book of Kells, it can be taken as a comparison to suggest that a page like 34r might have taken a month or so to complete. How long the whole manu-script would have taken to produce relates closely to the question of the number of artists and scribes who worked on it, and to the problem of its date and origin.

How long did it take to produce?

116. *Detail of folio 253v, an example of scribal correction.*

Vellum

The Book of Kells was written on prepared calfskin, otherwise known as vellum, from *vitulus*, the Latin word for calf. Skin preparation varied according to time and place, but the essential steps were that the hair was removed from the skin by immers-ing it in lime or excrement followed by working it with a knife. The skin was then tensioned on a frame, and a semi-circular *luna* knife used to remove what hair and debris remained. When the leaves had been cut to size, the pages were ruled for text with a wooden or bone instrument, following the guidance of prick-ings made on either side of the page with a stylus or the point of a knife. The physical make-up of the Book of Kells is unortho-dox in one respect. In most manuscripts, such as the Lindisfarne Gospels, the vellum was taken from the skins of uterine or very young calves and cut in bifolia so that the spine of the calf runs in a uniform way horizontally across the middle of the book.

Most of the gatherings of the Book of Kells are made up like this, but two gatherings contain a large number of leaves in which the spine of the calf runs vertically, in line with the spine of the book, and there is a scattering of single leaves where the spine runs vertically. These leaves, slightly thicker than the norm, were taken from calves which had been killed at roughly two or three months old. The artists preferred robust skins like these for pages of major decoration. In some cases, like folio 28, the spine of the calf can be observed running conspicuously down the middle of the page. This examination of the vellum assists in determining the number of calves used to produce the book, since only one bifolium could be produced from young or uterine calves, while older calves would normally have yielded two bifolia. By this calculation, which is necessarily imprecise, the Book of Kells in its original state used the skins of around 185 calves. By a further calculation, again imprecise, these would have been culled from a herd of over 1200 animals, or more if the book was produced in a short space of time. Such a large herd confirms the wealth of the monastery where the book was made. It prompts too the suggestion that the skins used in the Book of Kells came from more than one source, and that its production was supported by other monasteries in the Columban *paruchia*.[67] It was occasionally necessary to make use of available skins, whether they were perfect or not. Certain leaves, like folio 246, were disfigured by sizeable holes created in the flaying of the pelt. Here the scribe simply wrote around the hole, while in folio 316r the scribe has written over a patch. Many folios are disfigured by small holes. Once thought to have been caused by the warble fly, these are now thought to have resulted from bacterial damage caused by putrefaction during the preparation of the skin.

35

Writing materials and pigments

117. *Folio 30v, an unfinished page, showing the order in which the pigments were added.*

The portrait of St John (folio 291v) shows aspects of the technical expertise which lay behind the writing and decoration of the book. St John holds in his right hand a stylised version of a quill pen made from the tail feathers of a goose or swan. Scribes at the time also made some use of reeds. In his left hand, St John holds his gospel book, bound in red and purple. The majority of the books depicted in the manuscript have red bindings decorated with blind tooling, which probably convey an accurate impression of the original binding of the manuscript. At the evangelist's right foot is an inkpot, probably made from a cow horn stuck into the earth. Most of the text pages in the Book of Kells were written with a brownish iron-gall ink, made from

37

genuit achatn tionem babylo

achash genuit nis · & post tra

ezechiam eze ns migratione

chias autem babilonis · ie

genuit manas chonias genuit

sen manasses salathiel sala

h genuit am thiel h genuit

os amos autem sorobabel so

genuit iosiam robabel autem

iosias h genuit genuit abiud

ieconiam & abiud autem

fratres eius genuit eliachi

in transmigra eliachin

crushed oak apples and sulphate of iron in a medium of gum and water. A black carbon ink, made from lamp black or soot, was used on several preliminary pages in combination with red, purple and yellow script. The scribes used knives to excise mistakes. Painting was done with brushes of varying fineness, the finest perhaps made from marten fur. Drawings were constructed using compasses, dividers, set-squares, rulers and templates or 'French curves', and were underpinned by complex mathematical formulae.[68] The fineness of the decoration, which is especially marked on pages like 33r or 34r, raises the question 26,27 of whether the scribes could call on the assistance of magnifying instruments. Crystals may have been used, but they would probably have introduced an element of distortion.

The book employed a rich palette of organic and mineral pigments, some of which were imported from the Mediterranean region and were thus costly. The most expensive pigment was lapis lazuli, used for several shades of blue. This was known in the Middle Ages from only one source, a mine in north-east Afghanistan, and presumably reached Ireland in small quantities. Other blues were derived from the oriental plant indigo or from woad, native to northern Europe. Whites came from white lead and from chalk. Yellow was derived from orpiment (yellow arsenic sulphide), known as '*auripigmentum*' (gold pigment) in the Middle Ages. This shines out from the pages as a substitute for gold. Organic mauves, maroons and purples may have come from the Mediterranean plant *Crozophora tinctoria*. Red lead was used for most of the orange-reds in the book, with a kermes red produced from the pregnant body of the Mediterranean insect *Kermoccocus vermilio*. A copper green was used. This was unstable when damp and perforated the vellum in several places including the tunic of the rider on folio 253v. The binding medium was normally egg white. The order in which the pigments were used on the unfinished folios 29v–31r was that yellow orpiment was followed by an organic 117 purple, then by dotting in red lead. Pigments were applied in a complex variety of combinations and techniques. The Book of Kells employs the unusual colouristic technique, shared only with the eighth-century Lichfield gospels, of adding a thin translucent wash of one colour on top of another. A relief effect was frequently achieved through the layering of as many as three pigments on top of a ground layer. It is regrettable that this complex three-dimensional effect was largely lost when the leaves were wetted for flattening in the nineteenth century.[69]

This necessarily brief survey has attempted to convey something of what can be discovered about the Book of Kells. Much still remains uncertain. The precise relationship of its gospel text and decoration to that of other early gospel manuscripts is not established.[70] The minor decoration of the text pages has not yet been classified fully and evaluated. The relationship between scribe and artist is not known in detail. A precise place still has to be found for the Book of Kells in the development of zoomorphic initials in insular and continental manuscripts.[71] Some of the pigments, particularly the organic ones, have not been identified with certainty, and in the present state of knowledge they cannot be. Colour symbolism in the manuscript awaits further research. Meanwhile, the long debate among commentators in different disciplines concerning the origin of the manuscript and the date it was written remains unresolved, and from a historical perspective these are issues of the first importance.

Yet these uncertainties are part of the fascination of the Book of Kells. For over a thousand years it has remained an enigma, a work to be wondered at rather than understood. In many ways, Giraldus Cambrensis' description of a book he saw at Kildare in 1185 can stand as a description of the Book of Kells:

'It contains the concordance of the four gospels according to Saint Jerome, with almost as many drawings as pages, and all of them in marvellous colours. Here you can look upon the face of the divine majesty drawn in a miraculous way; here too upon the mystical representations of the Evangelists, now having six, now four, and now two, wings. Here you will see the eagle; there the calf. Here the face of a man; there that of a lion. And there are almost innumerable other drawings. If you look at them carelessly and casually and not too closely, you may judge them to be mere daubs rather than careful compositions. You will see nothing subtle where everything is subtle. But if you take the trouble to look very closely, and penetrate with your eyes to the secrets of the artistry, you will notice such intricacies, so delicate and subtle, so close together, and well-knitted, so involved and bound together, and so fresh still in their colourings that you will not hesitate to declare that all these things must have been the result of the work, not of men, but of angels.'[72]

Conclusion: 'The secrets of the artistry'

APPENDIX I: HISTORICAL BACKGROUND

No account of the Book of Kells can ignore St Colum Cille, abbot of Iona, with whose name it has been associated since the Middle Ages. Christianity was well established in Ireland, and supported by the aristocratic families, by the time Colum Cille was born in Donegal into the ruling dynasty of Uí Néill in 521 or 522, a great-great-grandson of Niall of the Nine Hostages, the founder of the dynasty. Around 561 Colum Cille travelled to Scottish Dál Riata with twelve companions from among his kin, including his uncle and his cousin and successor as abbot, Baithéne. It is not certain whether this was with the aim, as Bede claimed, of converting the northern Picts, or whether, as may be more likely, that mission grew out of his foundation of two monasteries. Colum Cille settled first on the island of 'Hinba', perhaps to be identified as Canna,[73] then on Iona, an island off Mull. Iona grew to be the prosperous head of a confederation (or *paruchia*) of monastic houses exercising wide influence over ecclesiastical affairs in Ireland and in the north of England, where Lindisfarne became its most prominent foundation.

A great deal is known about life on Iona from the writings of the seventh-century abbot, Adomnán (c 628–704), the author of several works including a life of St Colum Cille. Iona is a small island (only about 5.5 km from north to south and 2.5 km at its greatest width) but with enough land to support the arable and grazing needs of a sizeable monastic community.[74] Its position, however, left it exposed to the threat of Viking attacks which began towards the end of the eighth century. It was pillaged in 795, and again in 802. In 806, sixty-eight of the community were killed in another raid. The following year, the survivors migrated to Ireland and began to erect conventual buildings at Kells, probably in wood, on a site granted to them in 804. Kells had earlier been prominent as a prehistoric burial ground, an ecclesiastical foundation, and a royal hill-fort associated with the southern Uí Neill.[75] In the words of the Annals of Ulster, this was 'the new monastery of Colum Cille' (*noue ciuitatis Columbae Cille*). The church at Kells, probably a stone structure, was not completed until 814. At this point abbot Cellach resigned from Iona

and moved to Kells, leaving Diarmait installed as the new abbot of Iona. Cellach died the following year, still described in the Annals of Ulster as abbot of Iona. The annals are difficult to interpret on this point, but it seems that an overlap of abbots had taken place, perhaps because Cellach was elderly. From 814 until the death of Máel Brigte mac Tornáin in 927, it appears that the abbacy of Kells and Iona was held jointly, its abbot regarded as the successor of Colum Cille, located in the house of refuge at Kells. Iona continued to be occupied after the settlement of Kells in 814, and another Norse attack on it is recorded in 825, when Blathmac was murdered for refusing to reveal the hiding place of St Colum Cille's shrine ('*scrin*'). This was probably the chief relic of the founder, the chest containing his corporal remains. The historical record is not sufficiently precise to allow for certainty concerning which relics were on Iona at this date, in particular whether a great gospel book associated with the founder was there, or whether it could be counted among the relics of St Colum Cille which went from Kells to Iona in 829, and came back two years later. It appears, though from separate historical sources, one composed in Ireland and one in Scotland, that a division of relics took place in 849, when some relics were taken to Kells and others to Scotland, probably to Dunkeld. The Annals of Ulster record that Colum Cille's shrine and other relics arrived in Ireland in 878, having been brought in haste following another Norse attack, though it is not stated whether the attack was on Iona or, as Bannerman deduces, on Dunkeld. Given his reputation as a scribe, it would be surprising if there were no book by Colum Cille in this consignment, though again it is not known whether a gospel manuscript of late eighth- or early ninth-century date was included. It may be suggested that a gospel book of such recent manufacture would not necessarily have counted as a relic at all. Bannerman makes a case for concluding that such a manuscript, even one which we regard as highly as the Book of Kells, was placed beneath objects like the flabellum or the shrine itself in the hierarchy of Columban relics.[76]

The community which produced the Book of Kells must have been rich and stable, with a large

number of scribes and artists and an established library. This description would fit Iona before the raid of 795, or Kells in the period of calm it enjoyed after 814. It has not been possible however for scholars to agree on the date when the book was made and thereby fit it securely into either location. The date 'c 800' can be cited as a suitable compromise, and the manuscript attributed to the Iona scriptorium, whether working at Iona or at Kells or partially at both locations.[77] Features of the decoration, principally the fact that the book is uncompleted, support the dramatic scenario of monks fleeing Iona in a currach, clutching their great half-finished gospel book, while Norsemen wreak havoc behind them. A pronounced change in the form of the canon tables at canon IX from the arches of 1v–5r to the simpler grid style of 5v–6r was put forward by A. M. Friend in 1939 as evidence that the writing of the manuscript was interrupted by the Vikings and the subsequent move to Kells, but the occurrence of the same break in an earlier, fragmentary gospel book, British Library Royal 7.C.XII, makes such an explanation unnecessary.[78] Françoise Henry regarded Connachtach as the first scribe, working on Iona before the manuscript was completed at Kells. Connachtach was celebrated in a seventeenth-century compilation, the Annals of the Four Masters, as an eminent scribe and abbot of Iona, who died in 802. Although he was not known to the earlier and generally more informed Annals of Ulster, the record of his death may have made its way into the Annals of the Four Masters from a lost section of the earlier Annals of Tigernach. The status and succession of the abbots of Iona has not yet been established with certainty, but it may be taken that Connachtach was a historical figure, and one with a scribal expertise which was worth recording around the time when the Book of Kells was being written.[79] The texts of the canon tables and other prefaces in the Book of Kells derive from an exemplar which was very closely related to that used by the Book of Durrow.[80] Where the Book of Durrow itself originated is open to debate, though Dr Henderson has indicated a preference for Iona.[81] A detail of the decoration of folio 201r of the Book of Kells has been seen as another indication of its place of origin. The right hand of a figure (this may be a man, as usually supposed, or a woman, since breasts are shown) with fins and a double tail of a fish grasps the name of one of Christ's ancestors, 'Iona'. This does not allude to the island, which was known as 'Í' in the Middle

Ages, but may echo St Colum Cille's name in religion, 'Columba', the Latin word for 'dove', which was 'iona' in hebrew, as Adomnán had pointed out.[82] If it is a reference to the founder of the monastery – and such allusions are extremely rare – it is one which would apply equally to Iona or to Kells. Iona was well placed to act as an entrepôt for ideas and influences. The island received many visitors, such as the Gaulish bishop Arculf, who was blown off course on a journey home from the Holy Land and made his way to Iona during Adomnán's time. Adomnán took the opportunity to learn from him about the Holy Places, compiling a book on the subject which he presented in 686 or 688 to king Aldfrith of Northumbria, whose mother, incidentally, was Irish. It is not difficult to see a diffusion of information and artistic styles resulting from episodes such as this.

While Iona's claims are dominant at present, they are not conclusive, and it is difficult to escape the impression that no great quantity of evidence would be required for the pendulum of scholarly opinion to swing back, however inconclusively, towards Kells itself. In favour of an origin at Kells, there are pointers towards a date after 800 in similarities which Henry noticed with manuscripts produced in northern France around that date, principally the Corbie psalter (Amiens, Bibliothèque Municipale 18) and the Gellone sacramentary (Paris, Bibliothèque Nationale lat. 12048).[83] Manuscripts such as these are however no more susceptible than the Book of Kells is to precise dating. It may be that the production of a great gospel book was undertaken along with the erection of the cross of Saints Patrick and Columba as part of a programme of construction and decoration designed to enhance the prestige of Kells in its early years.[84]

A certain agnosticism over the question of provenance has followed the controversy associated with the name of the Belgian scholar François Masai, and his publication in 1947 of *Essai sur les origines de la miniature dite irlandaise*, a work which attempted to overturn the traditional attribution of the Book of Kells and other landmarks of Irish art to Ireland. For Masai, the Book of Kells was a product of the scriptorium of Lindisfarne, its inspiration Anglo-Saxon in origin rather than Irish. His follower, the palaeographer Julian Brown, put forward a case in 1972 for the Book of Kells having originated at an unknown scriptorium subject to Northumbrian influence in Pictland in eastern Scotland.[85] These views have become less

fashionable, and weight is now given to the inevitable intermingling of artistic influences which occurs with the movement of people and the objects they bring with them. While the Irish exercised a strong cultural influence on Northumbria through the monastic missions, there was also some English presence in Ireland in the same period, at, for example, the monastery founded by Colman for Englishmen in Mayo follow-ing the Synod of Whitby. Bede knew this as a distinguished and devout foundation.[86] There were Englishmen on Iona even in Colum Cille's time. Adomnán mentions two of them – Pilu, and an English lay brother, a baker by name of Genereus – though they were no doubt singled out because they were in a minority.[87]

APPENDIX II: LOSSES, ADDITIONS AND MARGINALIA

THE BOOK OF KELLS has not come through the centuries intact or unchanged. In the late eleventh and twelfth centuries, blank spaces in folios 5v–7r and 27r were used to record the details of property transactions of concern to the monastery of Kells.[88] The leaves now measure around 330 x 255 mm, but were severely cropped in the nineteenth century, and the edges were gilded. At present there are 340 folios, but around thirty folios, including some major decorated pages, have been lost. According to notes on folio 334v, the folios numbered 343 in the year 1588, one fewer than in the year 1621, when they were counted by James Ussher, then bishop-elect of Meath. At the beginning of the volume, an estimated ten leaves are missing. These may have contained Jerome's letter to pope Damasus, usually known by its opening words, *Nouum Opus*. Around twelve leaves have been lost from the end (John 17.13 – 21.25). Other textual gaps suggest the loss of roughly another six leaves in all, or twelve pages of text, at the end of the Hebrew names (after folio 26); at Mark 14.32–42 (after folio 177); at Luke 12.6–18 (after folio 239); and at John 12.28–13.20 (after folio 330).

A note by Gerald Plunket on folio 337r records the last of these gaps. As another note on the same page indicates, the bifolium in question was found in 1741. These pages had suffered severe water damage. Their pigments are largely washed out, and conspicuous iron staining is evident. The bifolium was folded the wrong way when it was rebound, and was numbered accordingly by J. H. Todd, Trinity College Librarian from 1852–69, when he foliated the manuscript in the lower left margin of each leaf. The mistake was not corrected until the Book of Kells received its present binding from Roger Powell in 1953, so that the leaves are now numbered in the order 336, 335.

Gerald Plunket has left many other annotations on the manuscript in his characteristic thin brown ink. He signed his name and initials on a number of pages; provided transcriptions of the text for folios 8r, 29r, 203r and 292r, usually in the tail margin; and imitated the artists in such efforts as his fish in the margin of 98v. Plunket interpreted folio 32v as a portrait of Christ, an identification with which most scholars would now concur, by writing 'JESUS CHRISTUS' in the spandrels of the arch on either side of the subject's head. In the nineteenth century, this phrase was concealed under obtrusive white paint, which now gives a misleading visual focus to the page.

Queen Victoria's contribution to the Book of Kells is well known. Visiting Ireland in August 1849, she and prince Albert were permitted to sign it, or so they believed. What they signed were modern flyleaves which were removed from the manuscript in 1953. Victoria was neither the first nor the last to succumb to the urge to fill its blank spaces. In the fifteenth century, a poem complaining bitterly about taxation on church land was written on the blank folio 289v. At the foot of the same page, Richard White, the rector of a small parish close to Kells, added some anodyne historical notes in the seventeenth century. Other contributions include the signature of Sir Thomas Ridgeway, Treasurer of Ireland in the early seventeenth century, on folio 31v. The monogram of John Obadiah Westwood, the author of the earliest modern account of the Book of Kells, appears with the date 1853 on folio 339r.

ABBREVIATIONS USED IN THE NOTES

Adomnán (1991)	*Adomnán's Life of Columba*, ed A.O. and M.O. Anderson, revised edn (Oxford 1991)
Age of Migrating Ideas	*The Age of Migrating Ideas. Early Medieval Art in Northern Britain and Ireland*, ed R. Michael Spearman and John Higgitt (Edinburgh 1993)
Alexander (1978)	J. J. G. Alexander, *Insular manuscripts, 6th to the 9th century*, A survey of manuscripts illuminated in the British Isles 1 (London 1978)
Bede, *HE*	*Bede's Ecclesiastical history of the English people*, ed B. Colgrave and R. A. B. Mynors (Oxford 1969)
CLA	*Codices latini antiquiores: a palaeographical guide to Latin manuscripts prior to the ninth century*, ed E. A. Lowe I–XI, Suppl (1934–72)
Farr (1989)	Carol Farr, 'Lection and interpretation: the liturgical and exegetical background of the illustrations in the Book of Kells', unpublished PhD dissertation, University of Texas at Austin (1989)
George Henderson (1987)	George Henderson, *From Durrow to Kells. The Insular Gospel-books 650–800* (London 1987)
Henry (1974)	Françoise Henry, *The Book of Kells: reproductions from the manuscript in Trinity College Dublin*, with a study of the manuscript by Françoise Henry (London 1974)
Ireland and Insular Art	*Ireland and Insular Art AD 500–1200*, ed Michael Ryan (Dublin 1987)
Kells commentary (1990)	*The Book of Kells, MS 58, Trinity College Library Dublin: commentary*, ed Peter Fox (Faksimile Verlag Luzern 1990)
Kells conference proceedings (1994)	*The Book of Kells. Proceedings of a conference at Trinity College Dublin, 6–9 September 1992*, ed Felicity O'Mahony (Scolar Press, for Trinity College Library Dublin, 1994)
Lewis (1980)	Suzanne Lewis, 'Sacred calligraphy: the Chi Rho page in the Book of Kells', *Traditio* 36 (1980) pp 139–59, at p 158.
Mayvaert (1989)	Paul Mayvaert, 'The Book of Kells and Iona', *The Art Bulletin* 71 (1989) pp 6–19
Ó Carragáin (1994)	Éamonn Ó Carragáin, '"*Traditio Evangeliorum*" and "*Sustentatio*"': the relevance of liturgical ceremonies to the Book of Kells', *Kells conference proceedings* (1994)
O'Reilly (1993)	Jennifer O'Reilly, 'The Book of Kells, Folio 114r: a Mystery Revealed yet Concealed', in *Age of Migrating Ideas* pp 106–114.
O'Reilly (1994)	Jennifer O'Reilly, 'Exegesis and the Book of Kells: the Lucan genealogies', in *Kells conference proceedings* (1994).
Werner (1994)	Martin Werner, 'Crucifixi, Sepulti, Suscitati: remarks on the decoration of the Book of Kells', *Kells conference proceedings* (1994)
Zimmermann	E. H. Zimmermann, *Vorkarolingische Miniaturen* I–IV (Berlin 1916–18)

NOTES

1 *Kells commentary* (1990) p 14.
2 The word 'insular', originally coined by the German palaeographer Ludwig Traube in 1901 to describe the script of the period in Britain and Ireland, has become commonly used as a broad and neutral term to describe the characteristics of the style in art and artefact as well as script. 'Majuscule' distinguishes the script as being of a higher grade than 'minuscule'.
3 Dáibhí Ó Cróinín, 'Ireland and the Celtic kingdoms of Britain', in *The Work of Angels. Masterpieces of Celtic Metalwork, 6th–9th centuries AD* (London 1989); idem, 'The Irish missions', in *The Celts* (Milan 1991) pp 659–662.
4 *Kells commentary* (1990) pp 153–65.
5 *The Annals of Tigernach. The Continuation, A.D. 1088–A.D. 1178*, ed. Whitley Stokes, *Revue Celtique* 18 (1897) p 12. The Book of Kells resembles the Book of Durrow closely in its prefatory material, and may have been termed the 'great' gospel book of Colum Cille in the annals in order to distinguish it from the lesser and earlier gospel book of the saint: '*libellum*', as the Book of Durrow is termed in its colophon. See *Evangeliorum Quattuor Codex Durmachensis* II (1960) pp 17–24. For the view that one of these books was not a gospel but rather the psalter known as the 'Cathach' of Colum Cille, see Máire Herbert, *Iona, Kells, and Derry* (Oxford 1988) p 93.
6 See the bibliographical references in Alexander (1978) pp 71–6.
7 Lewis (1980) p 158.
8 The Chi Rho is depicted decoratively on other pages, such as 62v, where it is made up of the body and paw of one lion and the leg of another. The same shape is found on 258r, formed by the tongue of one lion and the tail of another.
9 See O. K. Werckmeister, 'Die Bedeutung der "Chi" Initialseite im Book of Kells', *Das erste Jahrtausend. Text band* II, ed V. H. Elbern (1964) pp 687–710; Lewis (1980) ; George

Henderson (1987); Farr (1989); Carol Farr, 'Textual structure, decoration and interpretive images in the Book of Kells', *Kells conference proceedings* (1994); Ó Carragáin (1994); Werner (1994); O'Reilly (1993); O'Reilly (1994).
10 Lewis (1980) p 140.
11 John Higgitt, 'The display script of the Book of Kells and the tradition of insular decorative capitals', in *Kells conference proceedings* (1994).
12 See note 74.
13 Robert Stevenson, 'Further thoughts on some well known problems', in *Age of Migrating Ideas* pp 16–26.
14 Moyse's Hall Museum, Bury St Edmunds 1987–27.1, reproduced in *The Work of Angels. Masterpieces of Celtic Metalwork, 6th–9th centuries AD* (London 1989) p 143, § 136.
15 Henry (1974) p 182. The belief that 33r is now turned the wrong way, based on the artistic balance and colouristic values of the conjectural opening 33r/34r, is given some confirmation by codicological evidence. Most of the leaves of the manuscript have been trimmed more rigorously at the head than at the tail in the course of an unsympathetic binding in the nineteenth century. The head and tail margins of folio 33r conform to this pattern only if the page is turned upside down and faces folio 34r.
16 Bede, *HE* i.25.
17 Monumenta Germaniae Historia, Epistolae III (1892) p 60.
18 Ó Carragáin (1994).
19 Adomnán (1991) pp 208–9.
20 Adomnán (1991) pp 78–9.
21 Farr (1989) pp 344–5.
22 Werner (1994).
23 In the eighth-century Trier gospels (Trier, Domschatz 61 folio 9r), the archangels Michael and Gabriel are identified as such in introducing St Matthew's gospel.
24 Adomnán (1991) pp 14–15.
25 Alexander (1978) plate 265.
26 Adomnán (1991) pp 142–3.
27 Adomnán (1991) pp 14–15.

28 *Kells commentary* (1990) p 280; Werner (1994).
29 Henry (1974) pp 194–6.
30 Lewis (1980) p 140 n 4.
31 Anne Hudson, 'The Mouse in the Pyx: Popular Heresy and the Eucharist', *Eternal Values in Medieval Life*, edited by Nicole Crossley-Holland (*Trivium* 26, 1991) pp 40–53.
32 O'Reilly (1993).
33 Hilary Richardson, 'Remarks on the liturgical fan, flabellum or rhipidion' in *Age of Migrating Ideas* pp 27–34.
34 *Ireland and Insular Art* p 32 fig 3.
35 Snake motifs in the Book of Kells have been discussed in detail by Isabel Henderson, 'The Book of Kells and the snake-boss motif on Pictish cross-slabs and the Iona crosses', *Ireland and Insular Art* pp 56–65.
36 Ó Carragáin (1994).
37 Isabel Henderson, 'Pictish art and the Book of Kells', in *Ireland in Early Medieval Europe. Studies in Memory of Kathleen Hughes*, ed D. Whitelock, R. McKitterick, D. Dumville (Cambridge 1982) pp 79–105, at p 102.
38 Éamonn Ó Carragáin, 'The meeting of St Paul and St Anthony: visual and literary uses of a eucharistic motif', in *Keimelia: studies in archaeology and history in honour of Tom Delaney*, ed G. MacNiocaill and P. F. Wallace (Galway 1988) pp 1–58, at pp 4–5.
39 Michael Ryan, 'The menagerie of the Derrynaflan Chalice', *Age of Migrating Ideas* pp 151–161, at p 158.
40 Ó Carragáin (1994).
41 *Isidori Hispalensis Episcopi Etymologiarum sive Originum*, ed W. M. Lindsay, 2 vols, Oxford 1911 vol 2 lib XII. vii.48.
42 *The City of God* xxi.4.
43 Zimmermann plates 59, 57.
44 *ibid* plate 220b.
45 The model for the page has not been ascertained with any degree of certainty. It resembles what might result from a conflation of two images in the Godescalc gospel lectionary of 781–3, a product of the Carolingian court school (Paris, Bibliothèque Nationale nouv.

acq. lat. 1203). It is matter of debate whether the artists of Kells had access to such works of the Carolingian era as exemplars, but there are striking resemblances between the Book of Kells folio 32v and the Carolingian manuscript's portrait of Christ (3r) and the fountain of life (3v) taken together. Folio 32v of Kells portrays Christ and shares the flanking plant forms with folio 3r of the Carolingian portrait, but also takes over the flanking peacocks, the central cross, and the columns of the fountain itself from the other page, folio 3v, or one like it. The attitude of the peacocks' heads is the same in both manuscripts, though the tail coverts in Kells are constrained and dictated by the shape of the arch.

46 See the comments of Martin Werner in *Kells conference proceedings* (1994).
47 Zimmermann plate 277.
48 Adamnán (1991) p 5.
49 Zimmermann plate 3b.
50 *The Stowe Missal. MS D.II.3 in the library of the Royal Irish Academy*, Dublin, ed G. F. Warner II (London 1915) p 40. I owe this information to Dr Michael Ryan.
51 Henry (1974) p 200; Meyvaert p 6.
52 Zimmermann plates 14e, 15, 16b.
53 Zimmermann plate 19f; CLA 322.
54 Henry (1974) p 174.
55 Zimmermann plate 24c; CLA 406.
56 André Grabar and Carl Nordenfalk, *Early Medieval Painting from the fourth to the eleventh century* (New York 1957) p 130.
57 *Kells commentary* (1990) p 307.
58 O'Reilly (1994).
59 Pierre J. Payer, *Sex and the Penitentials. The Development of a Sexual Code 550–1150* (Toronto 1984) pp 40–44.
60 Michael Ryan, 'The menagerie of the Derrynaflan Chalice', *Age of Migrating Ideas* pp 151–161, at pp 156–7.
61 Henry (1974) p 212.
62 William O'Sullivan, *The Book of Kells. An introductory note to a selection of thirty-six colour slides* (Dublin 1967) p 3.
63 Henry (1974) pp 154–5.
64 Bernard Meehan, 'The division of hands in the Book of Kells', *Kells conference proceedings* (1994).
65 Timothy O'Neill, 'Book-making in early christian Ireland', *Archaeology Ireland* 3 (1989) pp 96–100, at p 99.
66 Mark Van Stone, 'Ornamental techniques in Kells and its kin', *Kells conference proceedings* (1994).
67 Bernard Meehan and Anthony Cains, 'Direction of the spine of the calf', *Kells commentary* (1990) pp 183–4.
68 Robert Stevick, 'Page design of some illuminations in the Book of Kells', *Kells conference proceedings* (1994).
69 See Anthony Cains, 'The pigment and organic colours', *Kells commentary* (1990) pp 211–231; Robert Fuchs and Doris Oltrogge, 'Colour material and painting technique in the Book of Kells', *Kells conference proceedings* (1994); Bernard Meehan, 'Aspects of manuscript production in the middle ages', *The illustrated archaeology of Ireland*, ed Michael Ryan (Dublin 1991) pp 139–43.
70 See the comments of Patrick McGurk, *Kells commentary* (1990) pp 61–9.
71 Much research remains to be done on parallels between the Book of Kells and particular continental manuscripts such as Paris, Bibliothèque Nationale, lat. 9427 or lat. 12168
72 *Kells commentary* (1990) pp 320–21.
73 J. L. Campbell, *Canna. The story of a Hebridean island* (Oxford 1984) pp 5–6.
74 Ian Fisher, 'The monastery of Iona in the eighth century', in *Kells conference proceedings* (1994).
75 D. L. Swan, 'Kells and its Book', in *Kells conference proceedings* (1994).
76 For discussion of the problems of St Colum Cille's relics, see Meyvaert (1989) p 11; George Henderson (1987) pp 179–98; John Bannerman, '*Comarba Coluim Chille* and the relics of Columba', *The Innes Review* 44 (1993) pp 14–47.
77 Henry (1974) pp 216–220. For a review of the problem, see J. J. G. Alexander, *Kells commentary* (1990) pp 288–9; Peter Harbison, 'Three miniatures in the Book of Kells', *Proceedings of the Royal Irish Academy* 85 C 7 (1985) pp 181–94, at pp 190–3.
78 Alexander (1978) p 74.
79 Henry (1974) pp 220–1. Henry regarded Connachtach as scribe 'A': see above p 91. I am grateful to Dr John Bannerman for advice on Connachtach.
80 Patrick McGurk, 'The texts at the opening of the book', in *Kells commentary* (1990) pp 57–8.
81 George Henderson (1987) pp 54–5.
82 Meyvaert (1989) pp 6–10.
83 Henry (1974) pp 215–9.
84 Françoise Henry, *Irish art during the Viking invasions (800–1020 AD)* (London 1967) p 138.
85 See Carl Nordenfalk, 'One hundred and fifty years of varying views on the early insular gospel books', in *Ireland and insular art* pp 1–6.
86 *Bede's Ecclesiastical history of the English people*, ed B. Colgrave and R. A. B. Mynors (Oxford 1969) IV.4.
88 See G. Mac Niocaill, *Kells commentary* (1990) pp 153–65; M. Herbert, 'Charter-material from Kells', *Kells conference proceedings* (1994).

A note on the Facsimile Edition

Reference has been made to the facsimile edition of *The Book of Kells*
produced by Faksimile Verlag, Lucerne, Switzerland, in 1990
and its accompanying volume of commentary.

This is the first time that the whole manuscript has been reproduced
in colour. All 680 elaborately illuminated pages are recreated down to the
finest detail, using up to ten different colours on a special paper resembling
the original parchment. Fine Art Facsimile Publishers of Switzerland
have developed a highly advanced process – a unique combination
of the most advanced electronic technology and ancient
craftsmanship, making it possible for the facsimile to be almost
indistinguishable from the original.

Handbound in fine white leather, the facsimile volume is supplied in a
magnificently hand-crafted presentation box and complemented by a
scholarly commentary volume, edited and introduced by Peter Fox,
with a foreword by Umberto Eco and contributions by J.J.G. Alexander,
Gearóid Mac Niocaill, Patrick McGurk, Bernard Meehan and
Anthony Cains.
These are available in English and German.

The Fine Art Facsimile Edition is limited to 1,480 copies world-wide,
and the price is $18,000. Further information, including an
illustrated brochure, can be obtained from:
FINE ART FACSIMILE PUBLISHERS OF SWITZERLAND
Maihofstrasse 25, CH-6000 Lucerne, Switzerland
Telephone: 41-360-380 Fax: 41-360 606